T0128058

LOOKING AT

Art

Peter V. Moak

Order this book online at www.trafford.com
or email orders@trafford.com

Most Trafford titles are also available at major online book retailers.

Printed in the United States of America.

ISBN: 978-1-4669-8399-1 (sc)
ISBN: 978-1-4669-8400-4 (e)

Library of Congress Control Number: 2013904755

Trafford rev. 05/03/2013

www.trafford.com

North America & international
toll-free: 1 888 232 4444 (USA & Canada)
phone: 250 383 6864 ♦ fax: 812 355 4082

LOOKING AT ART

For a work of art to look its best, it must be seen as it was seen when it was made. We have various ways of looking at the world. The particular way in which we need to see a work of art is one of these. Seeing a work in the right way is essential to its understanding and appreciation. From time to time, place to place, people to people, culture to culture, nation to nation, and artist to artist ways of seeing differ. This guide describes such differences.

THE VISUAL EGO AND THE VISUAL WORLD

We open our eyes and light enters through the lenses and forms pictures on our retinas. From these, our brain creates the world we see, our visual world. The visual world which appears to us as an upright, stable, and boundless lens projected image made up of objects and space. Objects diminish in size with distance according to the laws of optics while space is conceived as homogenous and does not change with distance. We are part of this world, both as those parts of ourselves we can see and as a central viewer located between the eyes which I call the visual ego.[1] We can not see our visual ego as it does our seeing. We experience its existence by the way the world looks. The visual ego can change in size, shape, distance, and orientation relative to an object. Orientation refers to whether an object is seen lined up with us, we with it, or unaligned. The changes in our visual ego help us to understand the visual world and to get around in a physical world which differs from the one we see. For example, things look small when far away. We compensate for this by reducing the size of our visual ego making a distant object seem close. This is called constancy scaling. By changing the size of our visual ego, we make both the large motion picture and the small television picture look life-size. A difference in orientation explains the phenomenon of seeing things either pass us or we them when we are moving. Things pass when oriented to us and we pass when oriented to them.[2] When an object is seen fixed in front of us, the visual ego can be made either larger or smaller. When smaller, the object is seen along a line of sight stretching out from the end of the ego to a point on a contour of the object. This oblique line of sight makes the object and the rest of the visual world more clearly three-dimensional. Conversely, when our visual ego is larger, a line of sight runs in from a point on the edge of the objet to end of the ego. This results in a less three-dimensional object. When a line of sight is conceived of as fixed contours in the rest of the visual world are seen successively seen aligned with the ego. When the ego is large, we are oriented to the object; and when the ego is small, the object appears oriented to us. An object observed to the side of the small ego is seen unaligned as is an object on the plane of the object seen to the side of the object when the ego is large. Unaligned objects appear relatively two-dimensional. Also, when we imagine space to the sides of our face, we get a very wide view of an unaligned visual world. The actions of the visual ego are coordinated with those of the eyes. Our eyes narrow when the ego is reduced in size and widen, look straight ahead, when the ego is large. If without shifting our eyes, we see an object to the side of an object with which we are aligned; continuity in the lines of sight between objects is established. When the eyes move to an adjacent object and the object is then seen aligned, new lines of sight are established and the object is seen visually isolated, disconnected. All this may seem strange and new, but it is not. These all are parts of normal vision. Things you do all the time. Becoming aware of the

size, shape, position, and orientation of the visual ego is all important when it comes to works of art. It is the particular use of the visual ego that holds a work of art together and makes it a work of art, a work of art being a thing made by a human being using the visual ego in a particular way.

PERSPECTIVES

The word perspective here refers to a particular use of the visual ego. The way a work of art looks depends on the perspective used in its making. When the correct perspective is used by the viewer, a work looks its aesthetic best. Aesthetic best is here considered universal, depending on the relationship between parts; and not a matter of taste, taste being a social or individual preference. Seeing the aesthetic relationship between the parts of a composition depends on using the correct perspective. Finding the right perspective is a matter of trial and error. The perspective that orients an object to the reduced ego is here called frontal perspective. Frontal perspective causes objects to be seen along diverging lines of sight that obliquely intersect contours of the object as with a lens-projected image, a photograph. The object-oriented large visual ego is here called oriental perspective. With oriental perspective, a line of sight runs out from the edge of the object to an end of the ego. Oriental perspective objects are seen clearly one at a time as units. Oriental perspective can provide a wide but less clear view. Frontal perspective provides a narrow view but a more three-dimensional object. Using frontal perspective in the context of a wide view can result in a composition that is both widely coherent and three-dimensional. With oriental perspective, nonalignment is achieved by seeing an adjacent object relative to the initial object across a plane. With frontal perspective, nonalignment is achieved when an adjacent object is seen in space to the side of the ego. The use of a particular perspective to make a thing seems unique to modern human beings, Homo sapiens. Objects made by animals and our ancient relatives, the Neanderthals, do not depend on a particular use of the visual ego; and so are not works of art. Differences in perspective form patterns in history of art. For example, different perspectives seem to follow the Noah's Ark theory for the peopling of the earth which begins in Africa and spreads from there. Changes in perspective can also follow the evolution of a culture. For example, Greek culture from the tenth through the first century BC. In Europe, as vast social and political changes occur from the first century BC to the twelfth century AD and beyond, perspectives accordingly change. Beginning in Spain in the eleventh century, standard perspectives begin to appear in the emerging nation states. In India and China, however, perspectives remain more or less the same. In the West during the following centuries, differences in perspective between individual artists become important. In the second half of the twentieth century, there is an effort to banish the constraints of perspective, of the visual ego.

Variations in perspectives help to determine the origins of a work of art. These variations include <u>nonalignment</u>, which can result in works made up totally of unaligned forms. See African and Oceanic art. The <u>wide view</u> resulting from oriental perspective makes for large

scale coherence. See Chinese art ca. AD 1400 to 2000. When the ego does not move relative to a composition, the <u>fixed ego</u>, three-dimensional continuity is enhanced. See the the works of Phidias and Ghiberti. The conceiving of a <u>space</u> around objects is used with various perspectives. See standard French perspective, space, and standard English perspective, no space. Objects can also be seen <u>reduced in scale</u>, smaller in size, or farther away. See standard Spanish or standard Italian perspective. When a point on the edge of a shape is oriented to the ego, the shape can be seen as a unit resulting in a composition of <u>large units</u>. Large unit composition is a characteristic of certain traditions and individual artists.[4] <u>Disconnection</u> here means an interruption of the lines of sight between objects. Disconnection occurs when the alignment follows the movement of the eyes. When lines of sight are first established with the next object, continuity is maintained. Seeing a form first aligned to the ego and then the ego aligned to it also creates discontinuity.

PERSPECTIVES USED IN THE HISTORY OF ART

Frontal Perspective

The frontal perspective object is seen fixed in front of the ego, isolated, and oriented to the visual ego. The ego is smaller than the object, the seems to occupy the same space as the object and lines of sight spread out to points on the contours of the object. The oblique lines render the object three-dimensional. Frontal perspective has a long history in the art of Semitic-speaking peoples and could be called Semitic perspective. It is found in works from tenth century BC Anatolia.

Oriental Perspective

When the visual ego is oriented to an object, it remains large; one is conscious of the space between one and the object, and the object is seen along a line of sight that runs from an edge of the object out to the end of the ego. This way of seeing and composing a work of art can provide a wide view, but only the part before one is seen clearly. Oriental perspective is a characteristic of works of art from the Far East, China, Southeast Asia, Central and Northeast Asia, Korea, and Japan.

Peripheral Perspective

Frontal and oriental perspective place one in front of an object. It is also possible to see an object from the side. This is done by orienting a point to the side of an object to the ego. This causes forms to be seen up close and at an oblique angle, and the composition as a sequence of separate parts. Peripheral perspective is a characteristic of the early art of the Indo-European speaking peoples and might be called Indo-European perspective.

Attic Perspective

Toward the middle of the fifth century BC, artists in Athens refined frontal perspective by imagining a point beyond the object oriented to the ego. Attic perspective reduces the ego to a

point thus refining the lines of sight. Attic perspective is used in Athens during the second half of the fifth century and the fourth century BC.

Hellenic Perspective

In the late fourth century BC, a perspective appears in Greece that suggests looking through a window. This method is based on imagining the plane oriented to the ego, in front of an object. The larger scale of this plane enlarges the ego and provides a wider view with objects which are still seen along diverging lines of sight. But the larger ego causes the lines of sight to be less oblique resulting in a less precise definition three-dimensional form. This perspective, here called Hellenic perspective, occurs in fourth century Greek art and during the Hellenistic period. I find it first used in seventh century BC Assyrian art.

Renaissance Perspective

At the beginning of the fifteenth century AD, the Florentine sculptor, Lorenzo Ghiberti introduces Renaissance perspective, a variation on frontal perspective. Renaissance perspective aligns an imagined point on the object to the ego. This reduces the ego to a point, keeps the ego at a distance, refines the angle between lines of sight, improves the representation of the third dimension, and enhances three-dimensional coherence. Renaissance perspective is not linear perspective, an invention of the fifteenth century Florentine architect, Filippo Brunelleschi. Brunelleschi's linear perspective is a geometric procedure based on optics with lines that converge to a point and does not depend on a particular use of the visual ego. Renaissance perspective is used by artists in Florence and Venice in the fifteenth and sixteenth century.

African Perspective

Frontal, Oriental and Peripheral perspective line up viewer and object. It is also possible to compose a work in which forms are seen unaligned. African perspective depends on imagining points in a composition, oriented to the ego and then seeing adjacent forms to side of the ego as nonaligned. African perspective is a characteristic of early works of art coming from a "path" stretching from sub-Saharan Africa into India.

Oceanic Perspective

Oceanic perspective aligns the ego to points in the composition. Adjacent forms are then seen as nonaligned across a plane relative to these points. Oceanic perspective is similar to African perspective in that compositions are composed of nonaligned forms. Oceanic perspective is a characteristic of early works of art coming from Southeast Asia, Australia, and Oceania.

Egyptian Perspective

The art of ancient North Africa and Egypt is based on a wide view provided by imagining space beyond the sides of the face which makes a portion of the composition appear unaligned. Forms in space in this context are then seen aligned to the ego. The Egyptian ego is round, providing a more vertical view and forms are seen reduced in scale.

European Perspective

Some of the oldest surviving representational works of art are those of Stone Age Europe, Old Europe. These are based on European perspective; forms aligned to the small ego with the divisions between parts not in space seen nonaligned by being seen to the side of the ego. Nonaligned divisions appear relatively two-dimensional and so decisively divide a composition. Nonaligned divisions also appear in Etruscan and Roman art.

THE VISUAL EGO AND THE HISTORY OF ART

◄○►

As you will see, art has the power of showing us how we see. The following observations are presented as evidence for the visual ego and its actions. It is up to the reader using trial and error to employ the perspectives described to decide if these observations are correct.

The African Tradition

The prevailing theory is that Homo sapiens sapiens, modern human beings, originated in sub Saharan Africa 200 to 100 millennia ago. Archeology places them in the Levant around 90,000 BC, and in Western Europe and Australia 40,000 years ago. Early works of art coming from a "path" stretching from sub-Saharan Africa, across the Middle East, Pakistan, and India to Southeast Asia, Indonesia, Australia, and Oceania are distinguished by the use of unaligned forms. Works of art coming from sub-Saharan Africa, the ancient Levant, the Mycenaean/ Minoan civilization, the Ubaid period in northern Syria, Protoliterate Mesopotamia, fourth century BC Iran, and the Indus Valley civilization are based on African perspective, points aligned to the ego and forms seen nonaligned relative to the ego. Early works of art coming from Southeast Asia, Indonesia, Australia, and Oceania are based on Oceanic perspective, nonaligned forms seen across the plane of the form.

Old Europe

The stone tools of Homo sapiens Neanderthalensis indicate that this species did not use a particular perspective in their making. See Neanderthal stone tools, 120,000—35, 000 BC, no perspective, from Le Moustier, France, the British Museum and flaked tools, ca. 70,000 BC, African perspective, from Howiesons Poort, South Africa, Pitt Rivers Museum, Oxford, England. This suggests that the visual ego, at least its particular use, is unique to Homo sapiens sapiens. Modern human beings are thought to have arrived in Western Europe 40,000 years ago. There are Upper Paleolithic works of art from Western Europe based on European perspective, frontal perspective no space with divisions seen nonaligned that date to around 25,000-20,000 BC. These include carvings in stone, ivory, and bone, and wall paintings from France and Spain. See *Venus of Willendorf*, ca. 30,000 BC Natural History Museum, Vienna. Neolithic works of art based on European perspective from the sixth through the fourth millennium BC include the ceramics of the Starcevo, Karanovo, Linearbandkeramik,

Bukk, Butmir, Vinca, Tisza, and Lengyel cultures. The Cucuteni culture of Moldova and the Western Ukraine seems an exception among the neolithic cultures of Central and Eastern Europe in its use of African perspective. African perspective is also used by the Thessalian Sesklo Culture. European perspective is a characteristic of neolithic works of art from Spain, France, Switzerland, Ireland, Britain, Poland, Germany, Scandinavia, Italy, and the western Mediterranean islands of Corsica, Sardinia, Sicily, Malta, and Gozo.

Egyptian Art

Egyptian art for most of its history is based on imagining space beyond the sides of the face which makes an area of a composition appear unaligned. Individual reduced scale shapes in space, in this context, are then seen aligned to a round ego. This perspective is used for works of art coming from Paleolithic North Africa, notably the Neolithic Tassili Culture, 7,000-6,000 BC of Algeria. From the Badarian Culture, 4,000-3,800 BC of the prehistoric Nile Valley come works of art based on African perspective. Works from the Nile valley Nagada Culture, 4,000-2,972 BC are based on Egyptian perspective. This suggests a migration into the Nile Valley of peoples from North Africa, the future Egyptians, during the upper paleolithic, ca. 4,000 BC. Early in the fourth millennium BC. Northern and Southern Egypt are united. Egyptian art from this time until the second half of the eighth century BC is based on Egyptian perspective. See *Narmer Palette,* ca. 3,000 BC Egyptian Museum, Cairo; *Menkaure and His Queen*, ca. 2,599 BC Museum of Fine Arts, Boston; the *Temple of Amun-Re Karnak*, begun ca. 1930 BC; the *Tomb of the Vizier Ramose*, ca, 1355 BC west of Thebes; the *Treasures of Tutankhamun*, ca. 1327 BC Egyptian Museum, Cairo; the *Temples at Abu Simbel*, ca. 1,250 BC and the *Golden Mask of Psusennes I, 1039-991 BC* Egyptian Museum, Cairo. During the reign of the Akhenaten, 1353-1337 BC Egyptian perspective employs a wider, nonaligned view. See *Stele of Akhenaten and Nefertiti with Their Three Daughters*, ca. 1345 BC Egyptian Museum, Berlin. During the eighth and seventh century BC the works of art of the Kushite kingdom in the south are in the Egyptian style, but depend on African perspective. See *Statue of Mentuemhet*, ca. 660 BC, Egyptian Museum, Cairo. Following the expulsion of the Nubians, the art of the twenty-sixth dynasty, 664-525 BC continues in the Egyptian style, but is based on frontal perspective, reduced scale forms in space. This perspective will persist through the Persian into the Macedonian occupations until around 144 BC when Hellenic perspective is introduced. See the Hellenistic *Temple at Edfu*, 116 BC. The use of Hellenic perspective will persist into the first century AD. See variously dated *Mummy Portraits* from the Fayoum, Cairo Museum.

The Ancient Near East

From the tenth, seventh, and sixth millennium BC neolithic Anatolia come works based on frontal perspective, forms not in space. See works from Gobekli Tepe, 9,600-8,200 BC and Catal Huyuk, 7,400-6,200 BC, both in Turkey. Works from Bronze Age Mesopotamia are

based on frontal perspective which replaces African perspective in Mesopotamia and Iran. Frontal perspective, forms not in space, is a characteristic of Sumerian, Akkadian, Babylonian, and Assyrian Art. See *Standard of Ur,* 2,600 BC British Museum; *Stele of Hammurabi,* ca. 1760 BC, the Louvre and the *Ishtar Gate,* from Babylon, 525 BC, State Museum Berlin. Seventh century BC. Assyrian works of art from the reign of Ashurbanipal are based on Hellenic perspective, forms not in space. See *Dying Lioness,* 650 BC, British Museum.

The Far East

Works of art coming from the Far East, China, Japan, Southeast Asia, and Central and Northeast Asia are based on Oriental perspective; large ego aligned to forms, converging lines of sight and space between viewer and object. This can provide a wide view, but to see parts clearly, the ego must move from part to part. An oriental composition is a journey across space in which forms come to life as we move. See Chinese *Bronze Ritual Vessels,* Chia Dynasty, 1523-1028 BC, Freer Gallery, Washington, DC and *Travelers on a Mountain Path,* Sung Dynasty, AD 960-1279 Taipei Palace Museum, Taiwan. An initial wide view becomes a standard of Chinese art in the fourteenth century AD. Japanese art differs from Chinese and the rest of oriental art by its large units seen in space. See Japanese; *Dotaku Bell,* 200 BC-AD 200 National Museum, Tokyo; the *Heigi Marogatami,* hand scroll, AD 1185-1333, Kamakura Period, the Museum of Fine Arts, Boston.

Pre-Columbian Art of the Americas

Oriental perspective, forms not in space, is a characteristic of the Pre-Columbian art of North, Central, and South America; the original inhabitants being from Asia. See *Coatlicue,* fifteenth century AD, National Anthropological Museum, Mexico City. Even today, the art of the Amerindians of North America and the peoples of Central and South American is generally based on oriental perspective.

The Indo-European Tradition

The early art of peoples speaking the Indo-European family of languages is distinguished by the use of peripheral perspective. A fixed place to the side of an object is aligned to the ego and the object, not in a surrounding space is seen obliquely aligned to the ego. This includes fourth millennium BC works from sites in the southern Ukraine, the probable Indo-European homeland; Hittite art; early Greek art; Celtic art; early German art; early Slavic art; early Baltic art; early Persian art; Indian art; and Tocharian art. Mid-second millennium, BC peripheral perspective works of art coming from the mid-Danube Valley indicate that by this time, Indo-European speakers were in the area.

Pre-Greek Art of the Aegean and the First Greek Art

Neolithic works of art of the Sesklo culture of the Thessalian plain in central Greece go back to the seventh millennium BC. These are based on African Perspective, unaligned forms not in space. See the *Sesklo Cup*, 5,900-5,800 BC, Volos Museum, Greece. The same perspective is used by the Mycenaean/Minoan civilization and Neolithic and Bronze Age works of art from the southern Greek mainland, various Aegean islands and Crete. See the *Lion Gate*, Mycenae, ca. 1,250 BC and the *Harvester Vase*, Ca. 1,500 BC Heraklion Museum. Late Bronze Age works of art from Crete are based on a wide view with forms seen nonaligned. From Crete, the Southern Greek mainland and various islands come small works in clay of the second half of the second millennium BC that are not based on African perspective, but on peripheral perspective, forms in space. This is a perspective used in Western Greece from the tenth to the late sixth century BC. See *Dancing Clay Figurines*, ca. 1200 BC Heraklion Museum. It would seem these humble works are made by the Greek-speaking people who we know from Linear *B* inscriptions were part of the Mycenaean/Minoan Civilization. Also of interest are mid-second millennium BC works from the mid-Danube valley which are based on this same peripheral perspective, suggesting that it is from this region that the Greeks come to Greece. See *Wheeled Vehicle*, from Dupljaja, ca. 1500 BC, Belgrade National Museum.

Greek Submycenean and Attic Protogeomeric Art

Eleventh century painted pots from the Kerameikos cemetery in Athens are based on African perspective. Tenth century pots from the Kerameikos are based on a perspective unique to Attica. Tan surfaces are seen aligned to the small ego and the black shapes not in space seen relative to the ego and unaligned. See *Dipylon Vase*, Dipylon Master, ca. 750 BC National Museum, Athens. This perspective which seems derived from African perspective is used in Attica until the second half of the eighth century BC.

Attic Geometric Perspective and Greek Peripheral Perspective

Eighth century BC works of art from Attica come to be based on Attic Geometric perspective, a place oriented to ego and adjacent area, in space, seen nonaligned. See *Kouros*, from Attica, ca. 600 BC Metropolitan Museum of Art, New York City. This perspective will be a characteristic of Athenian art until the mid-sixth century BC when it is replaced by peripheral perspective, forms in space. Elsewhere in the Greek world, peripheral perspective is used until the last quarter of the sixth century BC. In the west forms are seen in space and in the east without space.

Archaic Greek Art: Archermos, Phaidimos and Antenor

An initial wide view distinguishes the sculpture of Archermos, Phaidimos and Antenor, the first two sculptors of the sixth century BC, the Archaic period and the third of the early Classical period. To Archermos of Chios, is attributed the *Nike from Delos,* Athens National Museum, inscribed on base and *Kore no. 675,* Acropolis Museum, also inscribed. Both from the mid-sixth century BC and based on wide-view peripheral perspective, forms not in space. From slightly later come two major works by the Athenian sculptor Phaidimos, *The Calf Bearer,* Acropolis Museum, inscribed and the *Peplos Kore,* Acropolis Museum, attributed here on the basis of style and the use of wide-view peripheral perspective, forms in space. The works of Antenor of Athens, based on wide-view frontal perspective, forms in space, date from the late sixth into the early fifth century BC. These include: *Kore 681,* inscribed; *Kore 671,* on the basis of style and perspective, both, Acropolis Museum, Athens; the *Theseus and Antiope* from the *Temple of Apollo,* on the basis of style and perspective, Eretria, Chalkida Museum, Greece; the surviving *Sculpture of the East pediment of the Temple of Apollo,* Delphi, on the basis of perspective; the *Metopes, Treasury of the Athenians,* Delphi Museum, on the basis of perspective and most importantly, the *Head and Torso of Aristogeiton,* ca. 475, Conservatory Museum, Rome, which is original on the basis of style and perspective. The *Aristogeiton* is from Antenor's famous *Tyrannicides Group* that once stood in the Athenian Agora.

Phidias

The great Athenian sculptor Phidias succeeds Antenor as leader in the pursuit of the Classical style. Phidias use of the fixed ego is unique in Antiquity until the work of Lysippos in the fourth century BC. Thus, on the basis of style and the fixed ego, Phidias must be the Olympia Master, the creator of the *Pedimental Sculptures of the Temple of Zeus,* Olympia, 471-456 BC, Olympia Museum, which are based on fixed-ego frontal perspective, forms in space. The cohesiveness delivered by the fixed ego, along with the balancing of large and small three-dimensional forms and the blend of naturalism and abstraction acts to dramatically depict the events contained in the pediments. The *Temple of Zeus Metopes,* Olympia Museum, are based on frontal perspective, forms in space. They lack the precision and coherence of the pediments and are not by Phidias. The same difference exists between Phidias's *Zeus from Artemision,* ca. 455 BC Athens National Museum and its contemporary the *Charioteer,* ca. 460 BC, Delphi Museum. The *Charioteer* is relatively static. The frontal perspective forms in space are experienced in sequence rather than as a moment in time. Both the *Ludovisi "Throne,"* ca. 460 BC. Altemps Museum, Rome and the *Boston "Throne,"* ca. 447, Museum of Fine Arts, Boston, are based on the fixed ego and thus by Phidias. The differences in style are explained by differences in date and perspective. The *Ludovisi "Throne,"* ca. 460 BC is based on fixed-ego frontal perspective, forms in space. The *Boston "Throne,"* ca. 447 BC is based on fixed-ego Attic perspective, point oriented to the ego beyond the object, forms in space. The *Boston "Throne"* represents a new stage in Phidias's career. Fixed-ego Attic perspective precisely defines three-dimensional form and dramatically

enriches the large scale relationship between figures as seen on the front of the *Boston "Throne."* The *Parthenon,* was surely designed by Phidias having the fixed-ego coherence and visual "simultaneity" of Phidias's sculptures. The composition of parts, large and small is based on fixed-ego Attic perspective, forms in space. On the basis of fixed-ego Attic perspective, forms in space, two *metopes* from the *Parthenon Outer South Frieze, 1* and *30,* British Museum and one slab from the *Inner Frieze, West VIII,* in Athens, Acropolis Museum are by Phidias. All the other *Parthenon metopes* appear to be based on Attic perspective, forms in space. The inner frieze is based on wide-view Attic perspective, forms in space with the exception of *West VIII,* which is based on a wide-view, fixed-ego Attic perspective. This is the perspective Phidias uses during the final stage of his career. The *Parthenon Pediment Sculptures,* ca 435 BC now mostly in the British Museum with a few in Athens are based on Phidias's wide-view, fixed-ego Attic perspective, forms in space. The difference between Phidias's final two perspectives is demonstrated by his *Riace Warriors,* Reggio Museum, Italy. *Warrior A* is based on fixed-ego Attic perspective, forms in space. *Warrior B* is based on wide-view, fixed-ego Attic perspective, forms in space. The difference in perspective accounts for the leap in coherence between *A* and *B. Warrior B* has a fluidity and simultaneity that make it a supreme achievement of the Classical period.

In summary, the following works, dating from ca. 470 BC to ca. 430 BC on the basis of documentation, style and the use of three different fixed-ego perspectives are originals by Phidias:

1. The *Ludovisi "Throne,"* Altemps Museum, Rome, ca. 460 BC fixed-ego frontal perspective, forms in space.

2. The *Pediment Sculptures Temple of Zeus,* Olympia, Olympia Museum, 471-456 BC fixed-ego frontal perspective, forms in space.

3. The *Zeus from Artemision,* National Museum, Athens, ca. 455 BC fixed-ego frontal perspective, space.

4. *Head of Apollo,* Kassel Type, Conservatore Museum, ca. 455 BC, fixed-ego frontal perspective.

5. *Warrior A,* from Riace, Reggio Calabria Museum, ca. 450 BC, fixed-ego Attic perspective, forms in space.

6. *Boston "Throne,"* Museum of Fine Arts, Boston, ca. 447 BC, fixed-ego Attic perspective, forms in space.

7. *The Parthenon,* the Acropolis, Athens, begun 447 BC fixed-ego Attic perspective, forms in space.

8. *Parthenon Metopes, S1 and S30,* British Museum, ca. 445 BC fixed-ego Attic perspective, forms in space.

9. *Parthenon Frieze, Slab VII, West Frieze, 440-432 BC* Acropolis Museum, wide view, fixed-ego Attic perspective, forms in space.

10. *Parthenon Pediments,* British Museum and Acropolis Museum, ca. 435 BC, wide-view, fixed-ego Attic perspective, space.

11. *Athena Parthenos Statue and Shield,* Patras Museum, ca. 435 BC wide-view, fixed-ego Attic perspective, space.

12. *"Omphalos Apollo,"* Athens National Museum, ca. 435 BC wide-view, fixed-ego Attic perspective, space.

13. *Warrior B,* from Riace, Reggio Calabria Museum, ca. 435 BC wide-view, fixed-ego Attic perspective, space.

14. and 15. *Two Torsos in Greek Dress,* Metropolitan Museum of Art, ca. 435 BC wide-view, fixed-ego Attic perspective, forms in space.

Fifth Century Greek Art, the Classical Period

The most influential style in the history of art is that of fifth and fourth century Greece, the Classical style. Toward the beginning of the last quarter of the sixth century BC. Greek artists changed from using peripheral perspective, to frontal perspective. This produces more three-dimensional forms and more coherent compositions. Toward the middle of the fifth century, as seen in the work of Phidias, Athenian artists adopt Attic perspective, point beyond an object oriented to the ego, forms in space. This produces a more precise definition of three-dimensional form. Elsewhere in Greece, the norm is frontal perspective, space around forms in the West, no space in the East. Greek Classical compositions are balanced, three-dimensional and harmonious. The Classical figure harmoniously combines the natural and the abstract and for most of the Classical period, the young, idealized, nude, male figure is the principal subject. The Classical style is in contrast to the more rigid hard or early Classical style of the first half of the fifth century. (The so-called *Kritian Boy,* Acropolis Museum, is not a milestone in the development of the Classical style. The body is based on Attic perspective and should be dated ca. 450 BC. The head which does not belong is based on Hellenic perspective and probably, on the basis of style, a modern Greek fake.) Works in the Classical style include, the *Propylaea,* 437-432 BC and the *Erectheum,* including the *Frieze* and *Porch of the Maidens, 421-400 BC* Acropolis, Athens. They are both based on Attic Perspective, space around forms as is the *Hephaisteion* including the *Frieze,* begun 449 BC. Athenian Agora. A number of Athenian grave stele from the second half of the fifth century are based on Attic

perspective, space around forms including the *Cat Stele,* ca. 430 BC and the *Stele of Hegeso,* ca. 400 BC both in the Athens National Museum. Not long after the midcentury, led perhaps by the Achilles Painter, vase painting comes to be based on Attic Perspective, forms in space. Also based on Attic perspective, forms in space is Alcamenes's surviving original, *Prokne and Itys,* ca. 435 BC Acropolis Museum. Phidias's follower from Crete, Kresalis is responsible for several surviving originals including the *Portrait of Pericles,* ca. 425 BC, the British Museum and the *Head and Shoulders of Athena,* ca. 415 BC the Glyptotek, Munich. The *Athena Velletri* in the Louvre is a Roman copy of the entire statue. The *Head of Diomedes,* ca. 435 BC, the Museum of Fine Arts, Boston is also an original by Kresalis. All are based on Attic perspective, forms in space. Wide-view Attic perspective, seen in the later works of Phidias is not widely used, but is used for the *Temple of Athena Nike,* the Acropolis, including the *Nike Frieze on the Balustrade,* ca. 420 BC Acropolis Museum, Athens. Outside Attica, the Classical style is based on frontal perspective, forms in space in the West and no space, East.

Fourth Century Greek Art, the Late Classical Period

The Classical style changes little during the first half of the fourth century BC. Frontal perspective is the norm beyond Athens. See the *Temple of Apollo,* Bassae, the Peloponnesus, ca. 400 BC. The *Asklepion,* Epidauros, 380-70 BC and *Temple of Athena Alea,* Tegea, ca. 340 BC. In Athens Attic perspective is the standard. Kephisodothos statue, *Peace Holding the Infant Wealth,* ca. 370 BC once stood in Athens. The original headless body, minus Pluto, based on Attic perspective, forms in space is now in the Metropolitan Museum of Art, New York City. The original head, based on the same Attic perspective, is on a Greco-Roman body for a time on loan from Italy to the Museum of Fine Arts, Boston. The *Stele of Dexilios,* ca. 390 BC, Kerameikos Museum and the *Villa Albani Stele,* ca. 390 BC Rome, are both based on Attic perspective forms in space. The so-called *Mausolus and Artemisia,* along with blocks of the *Amazonomachy Frieze, 1006, 1014, 1015, 1020* and *1032,* the *Mausoleum,* Halicarnassus, 359-351 BC, the British Museum are based on Attic perspective, space, as is the *Column Drum, Temple of Artemis,* Ephesus, ca. 320, British Museum and the *Marathon Boy,* ca. 320, National Museum, Athens.

Praxiteles

The principal subject of Classical Greek art is the idealized, young, nude male figure. During the mid-fourth century, the Athenian sculptor Praxiteles, the son of Kephisodotos makes the first life-sized statue of an idealized, nude, young female, the *Cnidian Aphrodite,* ca. 350 BC now lost. There is, however, in the Heraklion Museum a wide-view Attic perspective forms in space half-sixed *replica of the torso of the Cnidian* from Gortyna, Crete. This on the basis of style and the use of wide-view Attic perspective, forms in space would seem to be an original by Praxiteles. In the same Heraklion Gallery is a *Head of Aphrodite* also based on wide-view Attic perspective, forms in space now on a Greco-Roman statue. This head seems the right

size for the torso. Using wide-view Attic perspective, forms in space which I believe unique to Praxiteles at this time as a guide, the following are other original surviving works by Praxiteles: *Pan*, ca. 350 BC in same gallery as *Aphrodite*, Heraklion Museum; a crouching *Aphrodite*, ca. 350 BC Altemps Museum, Rome and most marvelous of all, a clothed *Aphrodite*, ca. 350 BC Rethymnon Museum, Crete. The state of preservation is amazing. Her skin retains its polish and the drapery is transparent around her torso and flows from her hips like rushing water. She is a standard by which all surviving works of Classical Antiquity should be measured and she may indeed be the clothed *Kos Aphrodite* mentioned by Pliny. Her face is individualized and so may be a portrait of Praxiteles famous mistress, Phryne.

Lysippos

Lysippos of Sycon, active ca. 365—330 BC is the great Greek master of the second half of the fourth century BC. It would seem that it was Lysippos who introduces Hellenic perspective, forms not in space to Greece. The use of fixed-ego Hellenic perspective, forms not in space is unique to Lysippos in Antiquity. No originals by the prolific Lysippos are thought to survive. However, it seems on the basis of style and fixed-ego Hellenic perspective that the famous *Apoxyomenos*, ca. 350 BC, Vatican Museums, attributed to Lysippos by Pliny, is the original. Also on the basis of style and fixed ego Hellenic perspective, the following are originals by Lysippos: The *Lembach Hercules*, ca. 345 BC, Altemps Museum, Rome; the *Antikythera Youth*, ca. 335 BC, Athens National Museum; the *Erbach Head of Alexander*, ca. 335 BC Acropolis Museum and the famous *Hermes and the Infant Dionysos*, ca. 330 BC Olympia Museum. The *Apoxyomenos* is closest in style to the High Classical. Lysippos's Hellenic perspective forms are of necessity less precise than those produced by Attic perspective. The stretch into space is new. The *Antikythera Youth* is a further step away from the fifth century, while the *Olympia Hermes* in the flow of its forms and soft yet deep modeling is again new. Other original Athenian works on the basis of style and Attic perspective, forms in space, from the latter half of the fourth century include: *Head of Dionysos*, ca. 330 BC from the *Temple of Apollo*, Delphi, Delphi Museum; the *Eubouleus*, ca. 340 BC from Eleusis and the *Stele from the Ilissos*, ca. 330 BC Athens National Museum.

The Hellenistic Period

The Hellenistic period is the Greek world from the death of Alexander, 323 BC to the battle of Actium, 31 BC. Hellenic perspective, forms not in space is variously used at this time, but not world wide. Frontal perspective, forms in space, is the standard for Western Greek art including the Greek cities of Italy and Sicily. Frontal perspective, forms not in space is the norm in the East including the Macedonia and Seleucid kingdoms. Hellenistic perceptive dominates in Athens during the last quarter of the 4th century BC and the Hellenistic period. Examples include *Agias*, ca. 330 BC Delphi Museum; the *Demeter from Knidos*, ca. 325 BC the British Museum; the *Stele of Demetria and Pamphile, ca. 320 BC* Kerameikos Museum;

the *Stele of Aristonautes*, ca. 320 BC Athens National Museum and the *Themis*, ca. 300 BC from Rhammous, by Chairestratos, Athens National Museum. Hellenistic perspective, on the basis of coins, migrates from Athens to Pergamon in the first quarter of the 3rd century BC where it is responsible for the *Great Altar of Zeus*, 190 BC, Pergamon Museum, Berlin. The *Altar* is a work characterized by heightened emotion and a shift in the classical balance of large and small favoring the large. The *Aphrodite form Melos*, second century BC, the Louvre is based on Hellenic perspective, forms not in space. Rhodes is another center for Hellenistic perspective. Associated with Rhodes and based on Hellenic perspective, forms not in space is the *Winged Victory of Samothrace*, ca. 190 BC the Louvre; the *Head of Helios,* 3rd cent. BC, Rhodes Museum and the *Laocoon,* ca. 200 BC, Vatican Museums. Delos with its ties to Athens is also a center for Hellenic perspective. From Delos comes the Hellenic perspective, forms not in space, *Aphrodite, Eros and Pan*, late second century BC and the *Bronze Portrait Head,* ca. 200 BC both in the Athens National Museum. Around 144 BC "Egyptian" art comes to be based on Hellenic perspective which persists into the 1st century AD. See the variously dated *Faiyum Portraits*. Cairo Museum.

Villa Novan, Etruscan and Roman Republican Art

Bronze age works of art, ceramic pots and metal implements, from the north Italian Villa Nova Culture, 8th century BC, Tarquinia Museum, Italy, are based on European perspective, forms in space, divisions nonaligned which suggests that the Villanovan culture is a survival of Old Europe. Etruscan perspective is based on peripheral perspective, forms not in space, nonaligned divisions. See *Apollo from Veii*, ca. 510 BC, Villa Giulia Museum, Rome. Etruscan perspective seems a blend of Old Europe and Indo European perspective. Etruscan perspective survives into the 1st century BC in Etruria and Rome. See Etruscan perspective *Head of a Man*, Roman Republican, terra-cotta, ca. 50 BC Museum of Fine Arts, Boston. In the Greek south and Sicily frontal perspective, space around forms is standard. In the mid first century BC Etruscan perspective is replaced in Rome by frontal perspective, forms in space, nonaligned divisions. This change would seem to stem from the Island of Delos. During the second century, BC Delos is a center for the slave trade and a point of contact between Rome and Athens. From Delos come two new perspectives, in the West, a frontal perspective, forms in space, divisions nonaligned and in the East frontal perspective, forms not in space, divisions nonaligned. The Roman version persists for the next two and a half centuries. The Greek for the next eight centuries. The copy of the *Diadoumenos of Polyclitus*, first Century BC, from Delos, Athens National Museum, is based on the Eastern version. The *Augustus from Prima Porta*, ca. AD 20, Vatican Museums, exemplifies the Western version.

Art of the Roman Empire, First Through the Third Centuries AD

With frontal perspective a new style is established in Rome, the Julio Claudian, a revival of the Greek Classical style. The use of nonaligned divisions isolates the parts of theses works

providing for their individuality in contrast to the homogeneity of the Greek Classical style. Compare the statue of *Augustus from Prima* and its source, the two *Statues in Greek Dress,* by Phidias, ca. 440 BC Metropolitan Museum of Art, New York City. Early in the third century BC Roman art in the West, perhaps beginning in North Africa, returns to peripheral perspective, forms in space. See *Arches of Septimius Severus*, Rome, AD 203 and Leptis Magna, ca. AD 205 both based on peripheral perspective, forms in space. Peripheral perspective results in a composition made up of separate parts something that grows stronger as the century progresses. See the *Constantinian Reliefs, Arch of Constantine,* and the composition of the *Arch* as a whole, AD 312-315 Rome.

Early Christian and Byzantine Art

Fourth century AD Early Christian art from Italy is based on peripheral perspective, forms in space. This lasts until the Lombard conquest, eighth century AD when the forms are no loner seen in space. See the *Sarcophagus of Junius Bassus*, ca. AD 359, St. Peter's, Rome and the *Mosaics of St. Vitale*, ca. AD 547, Ravenna, Italy. The *Balustrade of the Patriarch Sigvald*, ca. AD 715-750 Cathedral Baptistry, Cividale, Italy is based on peripheral perspective, forms not in space. As the Greek speaking Eastern Roman Empire becomes the Byzantine Empire, frontal perspective, forms not in space and nonaligned divisions continues as the standard perspective. See Justinian's great church, *Hagia Sophia*, AD 532-535 Istanbul. Following the iconoclastic period, eighth and ninth century AD, Hellenic perspective, forms not in space, becomes standard in the Greek speaking world as it is today. See the fresco, *Harrowing of Hell*, AD 1310-20 *Church of Christ in Chora*, Istanbul.

Islamic Art

In sixth and seventh centuries AD a new religion and culture, that of Islam, sweep the Near East and Southern Mediterranean. Within twenty years Arabia, Syria, Egypt, Iraq and Iran are converted followed by the development of an Islamic art. In the East, including Egypt, the standard perspective is frontal perspective, forms not in space. See *Dome of the Rock*, AD 690 the Temple Mount, Jerusalem. In the West, North Africa and Spain, the standard perspective is frontal perspective, reduced scale forms in space, round ego. This seems to be a survival from prehistoric North Africa. See *The Great Mosque*, 985, AD Cordova, Spain.

Early Medieval Art from Western Europe

Europe from the midsecond millennium BC into the sixth century AD is impacted by the entrance of the Indo-European speaking peoples including Celts, Germans, Slaves, and Balts. The early art of these peoples is based on peripheral perspective, forms not in space. See *Sutton Hoo Treasure*, Saxon, seventh century AD the British Museum, London; the *Book of Kells,*

ca. AD 800 Trinity College Library, Dublin; the Carolingian, *Utrecht Psalter*, AD 820-832 University Library, Utrecht, the Netherlands and the *Abbey Church of St. Michael*, 1001-1033, Hildesheim Germany. Romanesque is a name given to Western European art from around 1050 to 1200 when the Gothic style begins to replace the Romanesque. Romanesque art is largely based on peripheral perspective, forms not in space, the perspective of the Indo-Europeans. A change to frontal perspective begins in Catalonia in the eleventh century and moves north, occurring at various times in various countries.

Art from Medieval Spain

In the early eighth century AD all of Spain except the Christian Visigothic Kingdoms to the north, Asturias-Leon, Navarre, Aragon and Catalonia becomes Islamic. The art of the Visigothic Kingdoms into the 12th century is based on peripheral perspective, forms not in space. See the *Portals of San Isidoro* ca. 1110, Leon. In contrast, the Islamic art of the south, al Andalus, is based on round-ego frontal perspective, reduced scale forms in space. See the *Great Mosque*, eighth to tenth century AD, Cordova. In the eleventh century, the Caliphate of Cordova breaks up into smaller "kingdoms" while the Christian kingdoms strengthen. At this time, round-ego frontal perspective, reduced scale forms in space, replaces peripheral perspective, forms not in space, in Catalonia. See *Lintel, Saint-Genis-des-Fontaines,* 1020, Catalan, now in France. This new perspective will become the standard for Spain as it is today.

Art from Medieval France

During the twelfth century, there is a transition in France from peripheral perspective, forms not in space, to frontal perspective, forms in space, which becomes the French national standard. The progress to frontal perspective begins in the south. See *St. Sernin,* 1070-1120, Toulouse; *Notre-Dame-la*-Grande, early twelfth century, Poitiers and *St. Gilles du Gard,* mid-twelfth century, all based on frontal perspective, forms in space. The architecture and decoration of the famous Romanesque churches to the north including *Saint Pierre,* 1115-1130, Moissac; the *Cathedral of St. Lazare,* 1120-35, Autun and *La Madeleine,* 1120-32, Vezelay are based on peripheral perspective, forms not in space, as is the Gothic *Ambulatory of St. Denis,* 1140-44, just outside Pairs and the *West Porch, Cathedral of Notre-Dame,* 1145-1150, Chartres. The *Cathedral of Notre Dame,* 1163-1250, Paris, is based on frontal perspective, forms in space as is French Gothic art to follow.

Medieval Art from England and Germany

As in Spain and France there is a progress in England from peripheral perspective to frontal perspective. *Salisbury Cathedral,* begun 1220, is based on peripheral perspective, no space while the *Crossing Tower,* 1334, is based on frontal perspective, no space; the new standard.

In Germany frontal perspective, forms not in space, does not replace peripheral perspective forms not in space and become the standard until the sixteenth century. See peripheral perspective, forms not in space, *Freiberg Cathedral*, 1260-1350, Germany. There is a cultural lag in Europe, South to North and West to East.

Medieval Art from Sicily and Italy

Frontal perspective arrives in Italy by way of Sicily where Norman rule replaces Moorish at the end of the eleventh century, 1091. Rather than use Norman, peripheral perspective, forms not in space, the Norman Christians, probably using Moorish artists use frontal perspective, reduced scale forms in space, a variation on the Islamic perspective of North Africa. See *Mosaics of Monreale Cathedral*, 1180-90, Sicily. Frontal perspective migrates to Italy, progressing south to north during the thirteenth century. See the frontal perspective, reduced scale forms in space, *Castel del Monte*, ca. 1240, Apulia, Italy, a hunting lodge of the Emperor, Frederick II. In contrast, *Santa Croce*, Florence, begun 1295, and the *Doge's Palace*, Venice, begun 1304 are based on peripheral perspective, no space. The Florentine Giotto di Bondone leads in the use of frontal perspective in Tuscany. Giotto's uses wide-view frontal perspective, reduced scale forms in space, for his powerfully coherent works. See *Scrovegni Chapel Frescos*, 1305, Padua. It would seem that it is the brothers Lorenzetti who introduce frontal perspective to Siena. See Ambrogio's *Allegories of Good and Bad Government*, 1338-40, Palazzo Publico, Siena and Pietro's *Birth of the Virgin*, 1335-42, Museo dell'Opera del Duomo, Siena, both wide-view frontal perspective, reduced scale forms in space. The change from peripheral perspective to frontal perspective is documented by the difference between Nicolo Pisano's peripheral perspective, forms not in space, *Pulpit*, 1259-60, the Baptistry, Pisa and Giovanni Pisano's frontal perspective, reduced scale forms in space *Pulpit*, 1302-10, Pisa Cathedral. Frontal perspective, reduced scale forms in space continues as the standard for Italian art today.

Renaissance Perspective and the Early Renaissance in Florence and Italy

Renaissance perspective first appears at the start of the fifteenth century in the competition to design the *North Doors of the Baptistery of S. Giovanni*, Florence, between seven Tuscan artists. The winner, working at the time as a painter is Lorenzo Ghiberti, the illegitimate, twenty-year-old adopted son of a goldsmith. Ghiberti's winning *Competition Piece, Sacrifice of Isaac*, 1401-2, Bargello Museum, Florence, is based on a point aligned to the ego on a reduced scale form in space, Renaissance perspective. Ghiberti is unique in the fifteenth century in combining Renaissance perspective with a wide-view and a fixed-ego. Compare his competition piece to Filippo Brunelleschi's also in the Bargello. The Brunelleschi, based on frontal perspective, reduced scale forms in space, is composed of individual passages held together by the moving ego. Ghiberti's on the other hand presents us with a cataclysmic moment in time, conveyed by the combined actions of Abraham, Isaac and the Angel simultaneously supported by all else in the composition. Works by Ghiberti to follow are: the *Designs for*

Stained Glass Windows, the *Cathedral of Florence,* 1409; the *North Doors of Baptistry,* Florence, installed 1424; the statues of *St. John the Baptist* together with the *Niche,* 1417 and *St. Stephen,* 1424, both formally on *Or San Michele*; the *Casa di Zenobia,* 1442, Florence Cathedral; the incredible *East Doors* of the Baptistry where jambs, frames, and every detail in the panels are seen from the same point. These were installed in 1452, three years before the artist's death. (The *East Doors* presently on the *Baptistery* are inadequate casts based on standard Italian frontal perspective. Panels from the original doors are on display in the Opera del Duomo Museum.) *The Dome of the Cathedral of Florence,* completed 1436, long attributed to Filippo Brunelleschi the builder, is based on a wide-view, fixed-ego Renaissance perspective, reduced scale forms in space, as is the *Model for the Dome,* ca. 1418, Opera del Duomo Museum. Thus Lorenzo Ghiberti not Brunelleschi was the designer of the *Dome of Florence Cathedral.* The works of Brunelleschi before ca. 1420 are based on frontal perspective, reduced scale forms in space, standard Italian perspective, as is his *Competition Piece* and the *Ospedale degli Innocenti,* 1419, Florence. After about 1420 he adopts fixed-ego frontal perspective, reduced scale forms in space. In about 1425, Brunelleschi invents linear perspective, a geometric procedure based on a fixed vanishing point opposite the viewing point. Linear perspective does not depend on a particular use of the visual ego. Brunelleschi's adoption of the fixed ego and the invention of linear perspective may have been inspired by the coherence of Ghiberti's works. Despite his great invention, Brunelleschi never discovered the secret of Renaissance perspective. It seems also to be unknown to the architect, Leon Battista Alberti, who writes a treatise on painting that explains linear perspective. Alberti uses Attic perspective, reduced scale forms in space. See his *Palazzo Rucellai,* 1446-51, Florence. Ghiberti's influence is far reaching and is particularly important for a number of artists who work for him. These include Michelozzo di Bartolomeo who's *St. Matthew,* 1422, for Or San Michele, usually attributed to Ghiberti, is based on the wide-view frontal perspective, reduced scale forms in space which is the perspective Michelozzo uses for the *Medici-Riccardi Palace,* 1444, Florence. Another who seems to have benefited from working with Ghiberti is the sculptor Donatello. See *St. George,* 1415-17, for Or San Michele, Bargello museum, based on Attic perspective, reduced scale forms in space. (The relief *St. George and the Dragon,* below the sculpture, is based on wide-view frontal perspective and so by Michelozzo.) Then see Donatello's *Jeremiah,* 1423-25 for the Campanile of the Cathedral, now in the Opera del Duomo Museum that is based on wide-view Attic perspective, reduced scale forms in space. Donatello's works to follow are based on wide-view Attic perspective. Another artist who may have benefitted from working with Ghiberti is Paolo Ucello. Ucello uses fixed-ego Renaissance perspective, reduced scale forms in space. See his *Sir John Hawkwood,* 1436, fresco, Florence Cathedral. The painter Benozzo Gossoli worked with Ghiberti and uses wide-view frontal perspective, reduced scale forms in space. See his *Magi Frescoes, Medici Palace,* 1459, Florence. His master, Fra Angelico, uses Renaissance perspective, reduced scale forms in space. See the, *The Annunciation,* 1440-50, fresco, San Marco, Florence. The painter Massolino may have worked with Ghiberti. He uses fixed-ego frontal perspective, reduced scale forms in space. Massolino's younger collaborator, Masaccio, uses Renaissance perspective, reduced scale forms in space. See *Frescoes of the Brancacci Chapel,* 1425, Sta. Maria de Carmine, Florence. Both Massolino and Masaccio employ Brunelleschi's new linear perspective. Fra Filippo Lippi who witnesses Massolino and Masaccio at work in the Brancacci Chapel, uses Renaissance

perspective, reduced scale forms in space. See *Madonna and Child,* 1437, National Gallery, Rome. Other fifteenth century Florentine artists using Renaissance perspective include the sculptor Bernardo Rossolino who uses Renaissance perspective, reduced scale forms in space for the *Tomb of Leonardo Bruni,* 1445, *Sta. Croce,* Florence. The architect, Guilio da Maiano uses Renaissance perspective, reduced scale forms in space for the *Pazzi Chapel Porch, 1461, Sta. Croce,* Florence. The sculptor Luca della Robbia also uses Renaissance perspective, reduced scale forms in space. See his *Cantoria,* 1435, Opera del Duomo Museum. Fixed-ego Renaissance perspective, reduced scale forms in space, is used by Andrea del Verrocchio, Leonardo's master. See *Equestrian Monument of Colleoni,* 1481-96, Venice. The same perspective is used by Sandro Botticelli. See his *Primavera,* 1482 and *Birth of Venus,* 1484-6, Uffizi Gallery, Florence. Another Florentine using Renaissance perspective, forms in space is Domenico Ghirlandaio. See *Calling of St. Peter,* 1481, Sistine Chapel, the Vatican. The painter and sculptor Antonio Pollaiuolo uses this same perspective for the *Tomb of Sixtus IV,* 1484-93, St. Peter's, the Vatican. The Florentine painter Andrea del Castagno uses a fixed-ego frontal perspective, reduced scale forms in space. See *Last Supper,* 1445-50, *S. Apollonia,* Florence. Piero della Francesca, from the Tuscan town of Borgo San Sepolcro, uses wide-view Renaissance perspective, reduced scale forms in space. See his frescos *The legend of the True Cross,* 1454-58, *S. Francesco,* Arezzo. Piero worked in Florence as an assistant to Domenico Veneziano, who uses wide-view frontal perspective, reduced scale forms in space. See *St. Lucy Altarpiece,* 1445-47, Uffizi Gallery, Florence.

Fifteenth Century in Venice and Italy

Renaissance perspective seems not to have been used in Italy during the fifteenth century beyond Florence and Venice. The leader of the Perugian school, the master of Raphael, Perugino, uses wide-view frontal perspective, reduced scale forms in space. See *Christ Giving the Keys to St. Peter,* 1481, Sistine Chapel, the Vatican. Andrea Mantegna, originally from near Padua and a brother-in-law of the Bellinis of Venice, uses fixed-ego frontal perspective, reduced scale forms in space, facilitating the proto Mannerist geometric intricacy of his work. See his *Altarpiece,* 1456-59, *San Zeno,* Verona. The most important fifteenth century Venetian painter using Renaissance perspective, reduced scale forms in space, is Giovanni Bellini. See the *Frari Altarpiece,* 1488, *Sta. Maria del Glorioso dei Frari,* Venice. Two other fifteenth century Venetian painters using Renaissance perspective, forms in space are Carlo Crivelli and Antonio Vivarini. See Crivelli's *Madonna and Child,* 1477, Vatican Museums and Vivarini's *Saint Ambrose Polyptych,* 1482, Accademia, Venice. Vittore Carpaccio uses fixed-ego, frontal perspective, reduced scale forms in space. See *Dream of St. Ursula,* 1495, Accademia, Venice.

The Early Renaissance in the North

French works of art from the fifteenth century are based on standard French perspective, frontal perspective, forms in space. See Claus Slater's *Well of Moses,* 1395-1406, Chartreuse de Champmol, Dijon, France. The *Avignon Pieta,* ca. 1445, the Louvre, considered by some

to be French is based on round-ego frontal perspective, reduced scale forms in space and so is probably Spanish. Standard English perspective is frontal perspective, forms not in space. See *Wilton Diptych*, ca. 1400, National Gallery of Art, London. Oil painting appears in the Southern Netherlands in the fifteenth century. See Robert Campin's *Merode Triptych*, 1425-32, Metropolitan Museum of Art, New York which is based on standard Belgium perspective, frontal perspective, forms in space. The left hand panel with the donor portraits is based on Renaissance perspective, forms in space making this probably a later work by Rogier va der Wyden. Jan van Eyk, creates extraordinary works in oil based on Hellenic perspective, forms in space. See the Brothers van Eyck, *Ghent Altarpiece*, 1432, St. Bavo, Ghent. The use of Renaissance perspective first comes North in the work of Petrus Christus. See *Freidsam Annunciation*, ca. 1435, the Metropolitan Museum of Art, New York City. Rogier van der Wyden begins using frontal perspective, forms in space. See *Decent from the Cross*, 1435, Prado Museum, Madrid. Later, he will use Renaissance perspective, forms in space. See *Saint Luke Panting the Virgin*, 1435-40, the Museum of Fine Arts, Boston. Two other fifteenth century Netherlandish painters using Renaissance perspective, forms in space are Dirk Bouts and Hugo van der Goes. See Bouts' *Last Supper*, 1464-68, St. Peter's, Louvin and van der Goes' *Portinari Altarpiece*, ca. 1476, Uffizi Gallery, Florence. Hans Memling uses fixed-ego frontal perspective, forms in space. See his *St. John Altarpiece*, ca. 1470, St. John's Hospital, Bruges. From the end of the century and the beginning of the next comes the work of Hieronymous Bosch. He uses fixed-ego Hellenic perspective, forms in space. See *Garden of Earthly Delights Triptych*, 1480-1515, the Prado Museum, Madrid. The unifying fixed ego encompasses the entire triptych giving it an extraordinary impact.

India

The art of the Indus Valley civilization, ca. 2500-1500 BC is based on African perspective. The early works, now lost, of the Indo-European speaking people who entered India ca. 1500 BC must have been based on peripheral perspective, forms not in space, which is to be the standard Indian perspective. See the *Great Stupa*, third to the first century BC, Sanci; the art of the Kushan period including Gandharan Art from northwest India, AD 50-320; medieval Hindu *Frescoes from the Ajanta Caves*, AD 500-550; the art of the Pablava period, AD 500-750; the famous *Temples of Orissa*, eighth to thirteenth century, and the eleventh century *Chola Bronzes*. The use of peripheral perspective continues during the Mughol dynasty, 1526-1756. See the *Taj Mahal*, ca. 1630-48, Agra, India.

The Far East and Southeast Asia

From its beginnings, Chinese art is based on oriental perspective, forms not in space. In the fourteenth century AD, during the Juan Dynasty, 1280-1368, a period of Mongol domination, a wide-view oriental perspective, forms not in space becomes the Chinese standard. See Ni Tsan's *Landscape*, ca. 1360, Freer Gallery, Washington, D.C. This perspective will hold

sway in China for the next four and half centuries producing a level of quality unmatched in the history of art except perhaps that of Ancient Egypt. Today in the late twentieth and early twenty-first century, the wide view is being dropped by Chinese artists perhaps in an effort to escape the past. Ironically, a return to oriental perspective, forms not in space, is a return to the past and a more traditional Chinese practice. Standard Japanese perspective is oriental perspective, large unit forms in space. See the hand scroll *The Heiji Monogatari*, twelfth century, Museum of Fine Arts, Boston. The Zen master Hakuin Ekaku uses oriental perspective, forms in space and disconnected passages. See *The Sound of One Hand*, eighteenth century, Private Collection. Another exception is Hiroshige Utagawa, who uses a wide-view, fixed-ego frontal perspective, large unit forms in space. See his wood block print *Rain Shower over the Ohashi Bridge*, ca. 1840.

Indian Buddhism and Hinduism have a far-reaching influence. In Nepal, Sri Lanka and for a time, Indonesia they carry with them peripheral perspective, forms not in space. See *Frescoes of the Great Rodi of Sigiriya*, AD 479-497 Sri Lanka and the *Temples at Borobudur*, late eighth-century AD Java. Elsewhere in Southeast Asia, the Far East, Tibet, Myanmar, Thailand, Cambodia, Vietnam, Mongolia, and Manchuria the standard is oriental perspective, forms not in space.

The High Renaissance, Florence and Rome

The High Renaissance begins with Leonardo da Vinci who initially uses fixed-ego Renaissance perspective, reduced scale forms in space. See *Adoration of the Magi*, 1481, Uffizi Gallery, Florence. For his *Last Supper*, begun 1498, *Sta. Maria delle Grazie*, Milan, Leonardo adopts wide-view, fixed-ego Renaissance perspective, reduced scale forms in space. At the end of his life, Leonard moves to France taking with him the unfinished *Mona Lisa*, 1503 and the *Madonna and Child with St. Anne*, 1508, both in the Louvre. Another hand finishes both. *Mona Lisa's* head, neck and background landscape are based on Leonardo's wide-view, fixed-ego Renaissance perspective, reduced scale forms in space. Her features, eyes, nose, mouth including the famous smile, and everything below the neck is based on frontal perspective, forms in space, standard French perspective. The same problem exists with the *Madonna and Child and St. Anne*. The oversized head of St. Anne and the lamb-wrestling Jesus are based on frontal perspective, forms in space and are not by Leonardo. Raffaello Santi is born in Urbino in 1483. The son of a painter, he is a student of Perugino. Rafael's initial perspective is Renaissance perspective, reduced scale forms in space. See *Marriage of the Virgin*, 1504, Brera Gallery, Milan. By 1505, he is working in Florence and some four years later in Rome decorating a series of rooms in the Vatican. By this time, his perspective is wide-view Renaissance perspective, reduced scale forms in space. See *School of Athens*, 1508-11, Stanza della Signatura, the Vatican. Michelangelo Buounarrati eight years older than Raphael is a Florentine. His *David*, 1501-4, Accademia, Florence, is based on Renaissance perspective, reduced scale forms in space. A *Wax Maquette for the David*, in the Museum of Fine is Arts, Boston is based on the same perspective as the David and most probably by Michelangelo. In

1508, Michelangelo is called to Rome to paint the *Sistine Ceiling*. The first half of the frescos is based on Renaissance perspective, forms in space. See *The Fall* and *Birth of Eve*, 1510, the Vatican. After a brief respite, Michelangelo finishes the *Ceiling* using wide-view Renaissance perspective, reduced scale forms in space. See the *Creation of Adam*, 1511. Raphael's use of the wide view near by in the Vatican may have inspired this change. In 1513, Michelangelo adopts wide-view Hellenic perspective, reduced scale forms not in space. See *The Last Judgment*, 1534-41, Sistine Chapel, the Vatican. It would seem this change was inspired by his interest in the *Laocoon*, found in Rome in 1506, Vatican Museums, a Hellenistic work from Rhodes, based on Hellenic perspective, forms not in space. Michelangelo will use Hellenic persecutive for the rest of his life including his designs for new *St. Peter's*. These include those parts east of the nave, the *Dome* and the *Facade*, with the exception of the *Side Towers* and *Central Loggia*. These belong along with the *Nave* to Carlo Maderno and standard Italian perspective. The *Dome* and *Facade* are executed after Michelangelo's death by Jaccomo della Porta, who uses Hellenic perspective, reduced scale forms in space. A less known aspect of Michelangelo's oeuvre are a number of pseudo-antique works of art. Style and perspective reveal that among these are: the *Head of the Apollo Belvedere*, Vatican Museums, Rome, Renaissance perspective, reduced scale forms in space; the *Head of the Medici Venus*, wide-view Renaissance perspective reduced scale forms in space, Uffizi Gallery, Florence; the *Bartlett Head*, Museum of Fine Arts, Boston, wide-view Renaissance perspective, reduced scale forms in space and the *Belvedere Torso,* Vatican Museums, Rome, wide-view Hellenic perspective, reduced scale forms not in space. Renaissance perspective was unknown in antiquity and reduced scale only in Egypt and North Africa. Two other major High Renaissance artists using Renaissance perspective, reduced scale forms in space are Fra Bartolomeo and Andrea del Sarto. See Fra Bartolomeo's *Vision of St. Bernard*, 1504-7, Accademia, Florence and del Sarto's *Madonna of the Harpies*, 1517, Uffizi Gallery, Florence. Bramante the predecessor of Michelangelo as architect of St. Peter's uses Renaissance perspective, reduced scale forms in space. See his *Tempietto*, 1502, Rome. Baldazarie Peruzzi uses Hellenic perspective, reduced scale forms in space. See his *Frescoes for the Villa Farnesina*, 1532, Rome.

The High Renaissance, Venice

Giovanni Bellini dies in 1516. His Venetian successor Giorgione uses fixed-ego Renaissance perspective, reduced scale forms in space. See *Sleeping Venus*, ca. 1510, Painting Gallery, Dresden. The background landscape is by Titian. Titian uses wide-view, fixed-ego Renaissance perspective, large unit, reduced scale forms in space. See *Bacchanal*, ca. 1517, Prado Museum, Madrid. The next generation of Venetian painters is lead by Tintoretto and Paolo Veronese. Tintoretto uses fixed-ego Renaissance perspective, reduced scale forms in space. See *Miracle of the Slave*, 1548, Accademia, Venice. Veronese also uses fixed-ego Renaissance perspective, reduced scale forms in space. See *Feast in the House of Levi*, 1573, Accademia, Venice. The painter Lorenzo Lotto and the architect Palladio uses Renaissance perspective, reduced scale forms in space. See Lotto's *Sacred Conversation*, 1520's, Kunsthistorisches Museum, Vienna and Palladio's *Villa Rotunda*, 1567-70, Vincenzo, Italy. El Greco, trained in Venice, uses standard

Greek perspective, Hellenic perspective, forms not in space. See the *Burial of Count Orgaz*, 1586, S. Tome, Toledo. Corregio; active in Parma, uses fixed-ego frontal perspective, reduced scale forms in space, for *Jupiter and Io*, ca. 1532, Kunsthistorisches Museum, Vienna.

Mannerism

Mannerism is the name given to the work of a group of sixteenth century Florentine artists and others of the generation following Michelangelo. The Mannerists give High Renaissance Classicism a twist by upsetting the classical balance between natural and abstract in favor of an exaggerated geometry. This produces emotionally charged works that are modernist or even postmodernist in attitude in undermining classicism. Several of these artists use fixed-ego frontal perspective, reduced scale forms in space, including: Pontormo a pupil of Andrea del Sarto, *see Entombment*, ca. 1526, St. Felicia, Florence; Rosso Fiorentino, *see Descent from the Cross*, 1521, Communal Painting Gallery, Verona; Bronzino, student of Pontormo who uses large units, *see Allegory of Venus*, ca. 1546, National Gallery, London and Parmigiano, *see Madonna of the Long Neck*, 1535, Ufizzi Gallery, Florence. The under appreciated Guilio Romano's masterpiece the architecture and frescos of the *Villa del Te*, 1527-34, Mantua, is based on wide-view frontal perspective, reduced scale forms in space.

The North, Sixteenth Century

French and English art of the sixteenth century is generally based on frontal perspective, space France, no space England. The Flemish Peter Breugel the Elder uses wide-view Hellenic Perspective, forms in space. See *Hunters in the Snow*, Kunsthistorisches Museum, Vienna. Germany enters the century still using peripheral perspective. Albrecht Durer begins with peripheral perspective, forms not in space. See *Four Horsemen*, woodcut, ca. 1500. He then switches of Renaissance perspective, forms not in space. See *Adam and Eve*, engraving, 1504. Albert Altdorfer uses wide-view Renaissance perspective, forms not in space. See *The Battle of Issus*, 1429, Pinakothek, Munich. Hans Holbein uses wide-view, frontal perspective, forms not in space. See *Henry VIII*, 1540, National Gallery, Rome.

The Baroque in Italy

At the start of the seventeenth century, there appear in Rome anti-Mannerist works that recapture the grandeur of the High Renaissance. At this time, artists are becoming increasingly individual with a number deviating from Italian standard perspective. Michelangelo inspires the new direction. Michelangelo's successor as architect of *St. Peter's* is Giacomo della Porta who uses Hellenistic perspective, reduced scale forms in space. *See Facade of Il Gesu*, 1575-1584, Rome. Della Porta's successor at *St. Peter's* is Carlo Maderno who uses standard Italian perspective, frontal perspective, reduced scale forms in space. The *Dome of St. Peter's*, completed by della

Porta, 1590, follows Michelangelo's design, but is based on della Porta's version of Hellenic perspective, reduced scale forms in space without Michelangelo's wide-view and forms not in space. The *Facade of St. Peter's* is based on della Porta's Hellenic perspective perhaps following a Michelangelo design. The *Nave* west of the crossing, the *Flanking Towers* and the *Loggia of Benediction* are based on Moderno's use of standard Italian perspective. Maderno's successor at *St. Peter's* is the architect and sculptor, Gian Lorenzo Bernini. Bernini uses Hellenic perspective, reduced scale forms in space. See his *Colonnade,* 1657, St. Peter's Square and his *David,* 1632, Borghese Gallery, Rome. Bernini's contemporary, the architect Francesco Borromini uses fixed-ego frontal perspective, reduced scale forms in space. See *S. Carlo alle Quarto Fontana,* 1638-57, Rome. The architect and painter, Pietro da Cortona, uses Hellenic perspective, reduced scale forms in space. See *Rape of the Sabines,* 1628, Capitoline Museum, Rome. The architect, Flamino Ponzio uses wide-view Hellenic perspective, reduced scale forms in space. See the *Cappela Paolina,* 1605-11, S. Maria Maggiore, Rome. Two schools of painters launch the new era. On one hand, there are the more traditional Bolognese led by Annibale Carracci and on the other, the revolutionary Caravaggio with his light and shadow "realism." Caravggio uses wide-view frontal perspective, reduced scale, lage unit forms in space. See *The Calling of St. Matthew,* 1599-1600, Contarelli Chapel, S. Luigi dei Francesi, Rome. Annibale Carracci uses fixed-ego Renaissance perspective, reduced scale forms in space. See *Farnese Gallery Ceiling Frescos,* 1597-1604, Rome. His cousin Lodovico Carracci uses fixed-ego frontal perspective, reduced scale forms in space. See *The Holy Family with St. Francis,* 1591, Civic Museum, Centro, Italy. The Carracci school includes a number of other major artists. Guido Rene uses Renaissance perspective, reduced scale forms in space. See *Aurora Fresco,* 1613, Casino Rospigliosi, Rome. Domenicino uses wide-view frontal perspective, reduced scale forms in space. See *Last Communion of St. Jerome,* 1614, Vatican Museums. Guercino uses a wide-view, fixed ego, Renaissance perspective, reduced scale forms in space to produce works of outstanding coherence. See *Aurora Fresco,* 1621-23, Villa Ludovisi, Rome. The peripatetic Luca Giordano uses fixed-ego frontal perspective for *Bachus and Ariadne,* 1685, Chrysler Museum, Norfolk, Va.

Seventeenth-Century Flanders

Standard Flemish perspective is frontal perspective, forms in space. Peter Paul Rubens uses wide-view Attic perspective, forms in space. See *The Garden of Love,* 1638, the Louvre. Antony van Dyke uses Attic perspective, forms in space. See *Portrait of Charles II Hunting,* 1635, the Louvre.

Sixteenth and Seventeenth-Century French Art

The art of sixteenth century France is based on standard French perspective, frontal perspective, forms in space as is much seventeenth century French art. Exceptions include the architect Louis le Vau who uses wide-view frontal perspective, forms in space. See *Chateau Vau-le-Vicomte,* 1657-61. The architect, Jules Haroudin-Mansart, uses wide-view Hellenic perspective, forms in space. See *Palace at Versailles,* 1669-1685. The etcher Jacques Callot

uses wide-view frontal perspective, forms in space. See his etchings *The Great Miseries of War*, 1653. Georges de la Tour also uses wide-view frontal perspective, forms in space. See *Joseph the Carpenter*, 1645, the Louvre. The Rome-based French painter Nicholas Pousin uses wide-view Hellenic perspective, forms in space. See *Rape of the Sabines*, 1636-7, Metropolitan Museum of Art, New York City. Claude Lorraine, the painter of classical landscapes and resident of Rome uses wide-view Hellenic perspective, forms in space. See *Sermon on the Mount*, 1650, Frick Collection, New York City. The painter Philipe de Champain uses Attic perspective, forms in space. See *Mother Agnes and Sister Catherine*, 1662, the Louvre. The sculptor, Piere Puget, uses fixed-ego frontal perspective, forms in space. See *Milo of Cortona*, 1671-82, the Louvre.

Seventeenth-Century Dutch Painting

Seventeenth century Holland produces a variety of accomplished artists working in a variety of genres. Many use standard Dutch perspective, frontal perspective, forms in space, but certain of the Dutch masters deviate from the standard to their great advantage. The brilliant Frans Hals uses wide-view, fixed-ego Hellenic perspective, forms in space. See *Women Regents of the Old Maids Home at Haarlem*, 1664, Frans Hals Museum, Haarlem. Rembrant uses wide-view Hellenic perspective, forms not in space until about 1661 when he turns to fixed-ego, wide-view Hellenic perspective, forms not in space. See *The Night Watch*, 1642, Rijksmuseum, Amsterdam and the fixed-ego *Return of the Prodigal Son*, ca. 1665, Hermitage Museum, St. Petersburg. Abroad today are many misattributed works and fakes. With Rembrant, the problem is acute. Many of the paintings, prints and drawings attributed to Rembrant are not based on Rembrant's Hellenic perspective, but on Dutch standard perspective. Rembrant had some fifty pupils. It would seem that he sold the work of these pupils as his own. This may have been the practice at the time, but it is still fraud. Seventeenth century Dutch artists not using standard Dutch perspective include Rembrant's pupil, Carel Fabritius who uses wide-view frontal perspective, forms in space. See *Linnet*, 1654, Mauritshuis, The Hague. Jan Vermeer uses Hellenic perspective, space around forms. See *Artist in His Studio*, ca. 1665, Art History Museum, Vienna. (*Girl With a Pearl Earring*, 1665, Maritshius, The Hague, is based on standard Dutch perspective and may be the work of Michiel Sweerts.) Gerard ter Borch use wide-view frontal perspective. See *Portrait of Hellen van der Schalhe as a Child*, 1644, Rijksmuseum, Amsterdam. Pieter de Hooch uses fixed-ego frontal perspective. See *Bedroom*, ca. 1669, National Gallery of Art, Washington DC. Gabriel Metsu uses Hellenic perspective, forms in space. See *The Sick Child*, 1660, the Rijksmuseum, Amsterdam. The landscapist Jan van Goyen uses wide-view Hellenistic perspective, forms in space. See *River Scene*, 1636, Fogg Art Museum, Cambridge, Mass. Salomon van Ruysdael uses wide-view frontal perspective, forms in space. See *Halt at an Inn*, 1649, Museum of Fine Arts, Budapest. Jacob van Ruysdael uses Hellenic perspective. See *Windmill Near Wijh*, ca. 1665, Ryksmuseum, Amsterdam. Meyndhart Hobbema uses wide-view frontal perspective, forms in space. See *Avenue at Middelharnis*, 1668, National Gallery, London. Willem Kalf, a still life painter, uses Hellenic perspective, forms in space, for *Still Life with Nautilus Cup*, ca. 1660, Private Collection.

Seventeenth-Century Spanish Art

Standard Spanish perspective beginning in the eleventh century is round ego frontal perspective, reduced scale forms in space. El Greco uses standard Greek perspective, Hellenic perspective, forms not in space. See the *Burial of Count Orgaz*, 1586, S. Tome, Toledo. Diego Velazquez uses wide-view, round-ego frontal perspective, reduced scale, large unit disconnected forms in space. This perspective seems unique to Velazquez at the time. See the *Maids of Honor*, 1656, the Prado Museum, Madrid. This is not the mysterious work so often described, but a some what informal royal portrait of the Princess appropriately centered in a group of retainers. Francisco Ribalta uses wide-view, round-ego frontal perspective, reduced scale forms in space. See *St. Francis Embracing Christ on the Cross*, ca. 1620. Provincial Museum, Valencia. The sculptor Gregorio Fernandez uses wide-view, round-ego frontal perspective, reduced scale forms in space. See *St. Bruno*, 1634, Valladolid Museum. The painter, Juisepe de Ribera, uses Renaissance perspective, reduced scale forms in space. See the *Martyrdom of St. Francis Bartholmeiu*, 1630, Prado Museum, Madrid. Estaban Murillo also uses Renaissance perspective, reduced scale forms in space. See the *Rest on the Flight into Egypt*, 1645, Detroit Art Institute.

Eighteenth-Century Italian Art

Standard Italian perspective continues to prevail in the eighteenth century. Gianbattista Tiepolo uses Renaissance perspective, reduced scale forms in space. See *Decorations of the Kaisersaal*, 1752, the Residence, Wurzburg, Germany. Gianbattista's brilliant son, Gian Domenica Tiepolo uses wide-view Hellenic perspective, reduced scale forms in space. See the *Villa Valmarana Frescos*, 1757, Vincenza, Italy. Landscapes featuring architecture, vedutas, are an important eighteenth century genre. Francesco Gaudi uses wide-view, fixed-ego, Hellenic perspective, reduced scale forms in space. See *Santa Maria della Salute*, ca. 1740, Ca' d' Oro, Venice. Canaletto uses wide-view Hellenic perspective, reduced scale forms in space. See *Basin of St. Marco*, 1730, Museum of Fine Arts, Boston.

Eighteen-Century French Art

Standard French perspective, frontal perspective forms in space, continues to prevail during the eighteenth century. Antoine Watteau uses wide-view frontal perspective, forms in space. See the *Embarkation for Cythera*, ca. 1717, the Louvre. Francois Boucher uses Renaissance perspective, forms in space. See *Rest on the Flight into Egypt*, 1765, Museum of Fine Arts, Boston. Jean-Honore Fragonard uses wide-view Renaissance perspective, forms in space. See *The Swing*, 1767, Wallace Collection, London. Jean-Baptiste-Simeon Chardin uses fixed-ego Hellenic perspective, forms in space. See *The Benediction*, 1740, the Louvre. Jean-Baptise Greuze uses wide-view frontal perspective, forms in space. See the *Village Bride*, 1761, the Louvre. Hubert Robert uses Renaissance perspective, forms in space. See *Demolition of Houses*,

1786-88, Carnavalet Museum, Paris. The sculptor Jean-Antoine Houdon uses Renaissance perspective, forms in space. See *George Washington*, 1788-92, State Capitol, Richmond, Va. The architect Jaques-Ange Gabriel uses wide-view frontal perspective, forms in space. See the *Petit Trianon*, 1762-68, Versailles.

Eighteenth-Century German Art

Standard German perspective beginning in the sixteenth century is frontal perspective, forms not in space. Johaun Fisher van Erlach uses fixed-ego frontal perspective, forms not in space. See the *Karlskirche*, begun 1715, Vienna. The architect Lucas von Hildebrandt uses wide-view Hellenic perspective, forms not in space. See *Upper Belvedere Palace*, 1721-24, Vienna. The French architect, active in Germany, Francoise de Cuvillies uses fixed-ego frontal perspective, space around forms. See the *Amalienburg*, 1734-39, near Munich. The sculptor Ignaz Gunter uses wide-view frontal perspective, forms not in space. See the *Guardian Angel*, 1763, Burgersaal, Munich.

Eighteen-Century English and American Art

Standard English perspective since the thirteenth century is frontal perspective, forms not in space which becomes the standard in North America. There is a survival in the seventeenth century in English vernacular art and the English colonies of North America of peripheral perspective, forms not in space. See *Mrs. Freake and Baby Mary*, 1674, Worcester Art Museum, Massachusetts. Amerindian art is based on oriental perspective, forms not in space. See *War Helmut*, nineteenth century, from south east Alaska, American Museum of Natural History. The leading English architects of the seventeenth century and eighteenth century use standard english perspective. Joshua Reynolds uses Attic perspective, forms not in space. See *Mrs. Siddons as the Tragic Muse*, 1784, Huntington Gallery, San Marino, Ca. Thomas Gainsborough uses wide-view Hellenic perspective, forms not in space. See *Mrs. Siddonds*, 1785, National Gallery, London. The America painters Benjamin West, John Singleton Copley and Gilbert Stuart use Hellenic perspective, forms not in space. See West's' *Death of Wolf*, 1770, National Gallery of Canada, Ottawa; Copley's *Watson and the Shark*, 1778, National Gallery of Art, Washington, D.C. and Stuart's *Mrs. Richard Yates*, 1793, Worcester Art Museum, Massachusetts.

Neoclassicism

The major changes in Europe during the second half of the eighteen century are reflected in the visual arts. It is a time of revolutions, philosophical, political and industrial. The beginning of the Modern age. Strangely enough at this time, Greek Classical art is rediscovered, but Neoclassicism represents not a revival, but a break with the past. From the Renaissance on the Classical style played an essential part in European art. The idealized human figure and the

Classical orders, a system of stories and bays, are organizing principals. Works are harmoniously both natural and abstract, and there is a balanced hierarchy of forms that conform to a sort of three-dimensional grid. The subject mater of major works tends to be based on literature. In the second half of the eighteenth century, a system I call, surface design, lines, and patterns that organize a composition more two-dimensionally overrides the Classical visual logic. This change spreads through the visual arts although the use of the standard perspectives continues. Anton Raphael Mengs uses Renaissance perspective, forms not in space. See *Parnassus*, 1761, Villa Albani, Rome. Antonio Canova uses Renaissance perspective, reduced scale forms in space. See *Pauline Borghese as Venus*, 1808, Borghese Gallery, Rome. In both cases surface design is important. The works of the Great Spanish painter Francisco Goya is Classical in the use of powerful three dimensional forms in space, but owes little to Neoclassicism. Goya, uses wide view Attic perspective, reduced scale forms in space and disconnection giving his images a unique force. See *The Third of May, 1808*, 1814-15, the Prado Museum. Madrid. The overriding influence of surface design is seen in the work of Jacques-Louis David. David uses wide view Attic perspective, forms in space. See the *Oath of the Horatii*, 1784, the Louvre Museum. His follower Piere-Paul Prud'hon uses wide-view Renaissance perspective, forms in space. See *The Empress Josephine*, 1808, the Louvre. The more romantic, Antoine-Jean Gross uses Hellenistic perspective, forms in space. See *Napoleon in the Pest House at Jaffa*, 1804, the Louvre Museum. The great English painter and poet William Blake uses wide-view peripheral perspective, forms not in space. See *Illustrations for Paradise Lost*, 1795, Tate Gallery, London. The Neoclassical style becomes the Federal style in the new United States. Thomas Jefferson stands out in his use of fixed-ego frontal perspective, forms not in space. See *Monticello*, 1770-1806, Charlottesville, Virginia. Benjanin Latrobe uses wide-view frontal perspective, no space. See Baltimore Cathedral 1805.

Romanticism and Realism

During the nineteenth century in Europe and North America the Neoclassical, Romantic and Realist styles coexist at first, but in time, Romanticism and then Realism take over. The Neoclassical style involves using style and subjects drawn from Antiquity. Line is most important and forms are exactly defined. Romanticism is more diverse. The range of subject matter increases, emotion is emphasized, nonclassical and exotic styles are imitated, exotic subjects are introduced, paint is applied variously and surface design continues. Realism rejects Antiquity and turns to nature and contemporary life as subject matter. Surface design continues and individualism is on the rise. Landscape and the observation of nature are all important, as is color and an inventive application of paint. The Neoclassicist, Jean Auguste-Dominique Ingres' precisely painted works become more Romantic in time. Ingres uses wide view Hellenic perspective, large unit forms in space. See *Odalisque*, 1814, the Louvre. Theodore Gericault a Romantic uses wide-view frontal perspective, forms in space. See the *Raft of the Medusa*, 1818-19, the Louvre. Eugene Delacroix, a leading Romantic, uses wide-view frontal perspective, large unit forms not in space for his richly colored works. See the *Massacre of Chios*, 1822-24, the Louvre. Gustave Courbet is the leading Realist. He explores the

textured use of paint while his subjects are the landscape, heroic everyday life and the figure. Courbet uses wide-view frontal perspective, forms in space. See *Burial at Ornans*, 1849-50. Honore Daumier, primarily a graphic artist, satirically distances himself from classical idealism. Daumier uses wide-view Hellenic perspective, forms in space. See the *Third Class Carriage*, 1863-65, Metropolitan Museum of Art, New York City. The history painter Ernst Meissonier uses wide-view frontal perspective, forms in space. See *Barricades*, 1849, the Louvre. The sculptor Francois Rude uses-wide-view frontal perspective, forms in space. See *The Marseillaises*, 1833-36, *Arch of Triumph*, Paris. The sculptor Antoine Louis Barye, famous for animals, uses Hellenic perspective, forms in space. See *Jaguar Devouring a Hare*, 1850-9, the Louvre. The innovative architect, Henri Labrouste uses fixed-ego frontal perspective, forms in space. See the *Ste. Genevieve Library*, 1843-50, Paris. From later in the century comes the medieval revival architect, Viollet-le-Duc who uses Hellenic perspective, forms in space. See *Tomb of Duc de Morny*, 1865, Paris. The Barbizon school of French landscape painters are pioneers of outdoor painting. Theodore Rousseau uses Attic perspective, forms in space. See *Under Birches*, 1843-43, Toledo Ohio Museum of Art. Francois Millet, a painter of heroic peasants and landscapes, uses wide-view Hellenic perspective, forms in space. See *The Gleaners*, 1857, the Louvre. The figure and landscape painter Camille Corot uses Hellenic perspective, forms in space. See his romantic, *Memory of Mortefontaine*, 1864, the Louvre. Thomas Couture, the teacher of Manet, uses Attic perspective, forms in space. See *Romans of the Decadence*, 1847, The Louvre. There is an outburst of creativity in nineteenth Germany. Caspar David Friedrich uses wide-view Hellenic perspective, no space, for his precisely painted landscape *Abbey in an Oak Forest*, 1804-10, National Museum, Berlin. Phillipe Otto Runge, uses wide-view frontal perspective, forms not in space. See *Hulsenbeck Children*, 1805-6, Kunst Halle, Hamburg. The Romantic Karl Blechen uses wide-view frontal perspective, forms not in space. See *Women Bathing in the Gardens at Tivoli*, 1830s. National Museum, Berlin. The Austrian Landscape painter Ferdinand George Waldmuller uses Renaissance perspective, forms in space. See *View of the Halslattersee*, 1838, History Museum, Vienna. From later in the century comes the history painter, Adolph von Menzel who uses wide-view frontal perspective, forms not in space. See the *Artists Sister with a Candle*, 1897, Bavarian State Collection, Munich. The figure painter, Hans von Marees, uses wide-view frontal perspective, forms not in space. See the *Hesperides*, 1857, New Pinakothech, Munich. The sculptor Daniel Rauch uses fixed-ego frontal perspective, forms not in space. See *Equestrian Monument* of *Frederick the Great*, 1836-51, Berlin. The architect Friedrich Schinkel uses Attic perspective, forms in space, for his Neoclassic *Old Museum*, 1824-30, Berlin. The nineteenth century is the great age of English landscape painting. Joseph Mallord Turner uses fixed-ego frontal perspective, forms not in space. See *Slave Ship*, 1840, Museum of Fine Arts, Boston. John Constable uses wide-view frontal perspective, forms not in space. See *The Hay wain*, 1821, National Gallery, London. Richard Parks Bonnington uses Hellenic perspective, forms not in space. See the *Park at Versailles*, ca. 1822, the Louvre. In the mid-nineteenth century the English Pre-Raphaelites, dedicated to a reform of the arts, use styles inspired by the early Renaissance and the meticulous observation of nature to explore history and everyday life. Standing out technically is John Everest Millais who uses wide-view Hellenic perspective. See *Christ in the House of His Parents*, 1850, Tate Gallery, London, both fictional history and everyday life. The eccentric Richard Dadd uses

Hellenic perspective, forms not in space. See *The Fairy Feller's Master Stroke*, 1858-64, Tate Gallery, London. The architect Phillip Webb uses wide-view frontal perspective, forms not in space. See *Red House*, 1859, Kent. The architect William Butterfield uses Hellenic perspective, forms not in space. See *Keble College*, 1873-6, Oxford.

It is during the nineteenth century that American art begins to come to the fore. The standard perspective is frontal perspective, forms not in space. The landscapist, Frederich Church, uses Renaissance perspective, forms not in space. See *Cotopaxi*, 1862, Private Collection. The German born and trained Albert Bierstadt uses Renaissance perspective, forms not in space. See *Rocky Mountains*, 1863. Metropolitan Museum of Art, New York City. William Sidney Mount uses fixed-ego frontal perspective, forms not in space. See *The Power of Music*, 1847, Cleveland Museum of Art. The landscape painter George Innes uses Renaissance perspective, forms not in space. See *Lackawanna Valley*, 1855, National Gallery of Art, Washington, D.C. James Abbot McNiel Whistler uses wide-view frontal perspective, forms not in space. See *Symphony in White, Number Two*, 1864, Tate Gallery, London. John Singer Sargeant uses fixed-ego frontal perspective, forms not in space. See the *Boit Daughters*, 1882, Museum of Fine Arts, Boston. Windslow Hommer uses Attic perspective, forms not in space. See *Snap the Whip*, 1872, Butler Institute, Youngstown, Ohio. Thomas Eakins uses fixed-ego Attic perspective, forms not in space. See *The Gross Clinic*, 1875, Philadelphia Museum of Art. Albert Pinkham Ryder uses wide-view Hellenic perspective, forms not in space. See *Siegfried and the Rhinemaidens*, 1888-91, National Gallery of Art, Washington, D.C. The sculptor Augustus Saint Gaudens uses wide-view Hellenic perspective, no space, large units. See *Shaw Memorial*, 1884-97, Boston. The sculptor, Daniel Chester French, uses Hellenic perspective, forms not in space. See *Minute Man*, 1873-74, Concord, Mass. The architect Henry Hobson Richardson uses wide-view Hellenic perspective, large unit forms not in space. See *Marshall Field Warehouse*, 1885-87, destroyed, Chicago, Illinois. The Philadelphia architect Frank Furness uses fixed-ego frontal perspective, forms not in space. See *Pennsylvania Academy of Fine Arts*, 1871-76, Philadelphia, Pa.

Impressionism

Impressionism, a new style, unlike anything before, is radical in the use of color and a loose application of paint. Impressionism comes from Courbet, the French Barbizon school of open air painting and the work of Edouard Manet. The first group show is in 1874. Loosely applied separate strokes of paint that vary in color interact visually to capture color and light as seen in nature. Still life, everyday life, sometimes figures and the landscape above all are its subject matter. The work is consistently three-dimensional, the leading artists are much aided by personal perspectives and open-air painting is a way of life for a number. The older Edouard Manet, a brilliant colorist, in time becomes more of an Impressionist. Manet uses wide-view Attic perspective and large unit disconnected forms in space to produce radically different compositions. See the *Luncheon*, 1863, the Louvre. Paul Cézanne, sometimes a member of the group, will bestride both Impressionism and Post Impressionism. The core group of

Impressionists are Claude Monet, Camille Pissaro, Pierre-Auguste Renoir, Alfred Sisley, Edgar Degas, Berth Morisot, Frederich Bazille (killed in the Franco Prussian war) and the painter and collector Gustave Caillebotte. Monet uses fixed-ego Attic perspective, forms in space. After 1900 he uses wide-view Hellenic perspective, forms in space. See his Attic *Bridge at Argenteuil*, 1874, d'Orsay Museum, Paris, and his Hellenic *Clouds*, 1916-26, Orangerie Museum, Paris. Camille Pissarro uses fixed-ego frontal perspective, forms not in space. See *Red Roofs*, 1877, d'Orsay Museum, Paris. The English, Alfred Sisley, uses wide-view, fixed-ego Attic perspective, large unit forms not in space. Sisley's subtlety of form and color set him apart. See *Flood at Marly*, 1876, d'Orsay Museum, Paris. Renoir, uses wide-view, fixed-ego Hellenic perspective, forms in space. See *Moulin de la Galette*, 1876, d'Orsay Museum. Edgar Degas, uses wide-view Hellenic perspective, forms in space. See L'Absinthe, 1876, d'Orsay Museum. Berthe Morisot also uses wide-view Hellenic perspective, forms in space. See *The Cradle*, 1873, d'Orsay Museum, Paris. Frederich Bazille, uses Hellenic perspective, forms in space. See *Summer Scene, Bathers,* Fogg Museum, Cambridge, Massachusetts. Gustave Caillebotte uses oriental perspective, forms in space. See *Paris Street Scene, Rainy weather*, 1877, Art Institute Chicago. The German Impressionist Max Liebermann uses Renaissance perspective, forms not in space. See *Dutch Sewing School*, 1876, Van der Heydt Museum, Wuppertal, Germany. The sculptor, August Rodin, who is associated with Impressionism, uses wide-view Hellenic perspective, forms in space. See *Burghers of Calais*, 1886, Calais, France.

Post Impressionism

There are four major artists identified as Post Impressionists: Georges Seurat, Vincent van Gogh, Paul Gauguin, and Paul Cézanne. Each has an individual style that radically differs from Impressionism and each uses a different, non standard perspective. The French Seurat regularizes impressionism by a system of dots. Seurat uses fixed-ego frontal perspective, forms in space. See *Sunday Afternoon on the Grand Jatte*, 1884-86, The Art Institute Chicago. Seurat's follower, Paul Signac, also uses fixed-ego frontal perspective, forms not in space. See *Portrait of M. Felix Feneon*, 1890, Private Collection. The Dutch Van Gogh uses wide-view Attic perspective, large unit forms in space, a palette of strong colors, wide, strongly patterned brush strokes and disconnection to produce his emotionally charged works. See the *Night Cafe*, 1888, Yale University Art Gallery, New Haven, Conn. The French Paul Gauguin begins as an impressionist, but moves to a style based on a pattern of richly colored shapes using standard French perspective. Then in 1889 after seeing art from Java at the Paris Worlds Fair, he begins using wide-view peripheral perspective, forms in space to produce even more richly colored, strongly patterned works. In 1991, Gauguin moves to Tahiti. See *Ia Orana Maria*, 1891, Metropolitan Museum of Art, New York City. Mysteriously from time to time, he reverts to using standard French perspective.

Cézanne

Paul Cézanne is both the most conservative and radical of the Post Impressionists. Cézanne uses a peculiar perspective that comes naturally to him. He begins with a wide-view, oriental perspective. In this context, his ego follows his eyes to produce disconnected large unit reduced scale forms in space. Cézanne uses this procedure to create complex yet coherent compositions composed of individualized parts. Cézanne's works have a history of being first ridiculed as incompetent and then later praised as individual and creative, but naive for his same perspective "inconsistencies." Tragically, some eighty of Cézanne's paintings among them major works have been ruined by repainting outlines using frontal perspective, probably at the behest of his dealer, Ambroise Vollard. Two perspectives can not be mingled in the same work of art without destroying its integrity. In about 1885, Cézanne modifies his perspective by fixing the ego, thus enhancing three-dimensional continuity. Cézanne does not rely on surface design and his works are never to be seen as flat. See the moving ego *Turn in the Road*, 1879-82, Museum of Fine Arts, Boston and the fixed ego, *The large Bathers*, 1906, Philadelphia. Museum of Art.

Late Nineteenth-Century Art

During the late nineteenth and early twentieth century, there appears in Europe a new style among other things called Art Nouveau. Art Nouveau typically involves a strong surface design of curving lines. It is manifested in painting, sculpture, architecture and in particular the decorative arts. The Barcelona architect Antonio Gaudi uses round ego wide-view Hellenic perspective, reduced scale forms in space. See the *Casa Mila*, 1905, Barcelona. The Belgium architect Victor Horta uses fixed-ego, frontal perspective, forms in space. See *Tassel House*, 1892-93, Brussels. The American architect Louis Sullivan, uses Hellenic perspective, large unit forms not in space. See the *Guaranty Trust Building*, 1894-95, Buffalo, New York. Henri Toulouse Lautrec, famous for his curvilinear posters, uses wide-view Hellenic perspective, large unit forms in space. See his poster, *Jane Avril*, 1899. The Norwegian painter, Edvard Munch, uses Hellenic perspective, forms not in space. See *The Dance of Life*, 1900, National Gallery, Oslo. Two leading members of a group of French artists called the Nabis, Prophets are Edouard Vuillard and Pierre Bonnard. Vuillard uses wide-view frontal perspective, forms in space. See *The Workroom*, 1893, Smith College Museum of Art, Northampton, Mass. Bonnard uses fixed-ego frontal perspective, forms in space. See his lithograph, *Nursemaids*, 1899. The sculptor Aristide Maillol uses wide-view Hellenic perspective, forms in space. See his stone sculpture *Night*, 1902, Art Museum, Winterthur, Switzerland. The Symbolist Achille Redon uses fixed-ego frontal perspective, forms in space. See his lithograph, *Marsh Flower*, 1885. The Belgium James Ensor uses wide-view Hellenic perspective, forms in space. See *The Entry of Christ into Brussels*, 1888, Private Collection.

The Fauves

From early in the twentieth century come a group of French painters called the Fauves, wild beasts. They produce freely painted, brightly colored works inspired by Gauguin and van Gogh. Maurice Vlaminck and Raoul Dufy use standard French perspective, frontal perspective, forms in space. Andre Derain also uses standard French perspective until sometime in 1906 when he switches to peripheral perspective, forms in space. See his frontal perspective, *London Bridge*, 1906, Museum of Modern Art, New York City and his peripheral perspective, *Turning Road*, 1906, Museum of Fine Arts, Houston. Georges Rouault uses wide-view frontal perspective, forms in space. See *Old King*, 1916, Carnegie Museum, Pittsburgh, Pa. Georges Braque, the future cubist, uses a narrow Oriental perspective, forms in space. See *Boats on Beach*, 1906, Los Angeles County Museum. Henri Matisse begins with wide-view Hellenic perspective, forms in space, then in 1904-5 invents a new perspective. See his Hellenic perspective *Carmelina*, 1903, Museum of Fine Arts, Boston. The "primitive" Henri Rousseau is not a Fauve, but is active and gains recognition at this time. Rousseau uses wide-view frontal perspective, forms in space. See *Sleeping Gypsy*, 1897, Museum of Modern Art, New York City.

Henri Matisse

Henri Matisse, a master of Modern Art, develops two new perspectives. He originally uses wide-view Hellenic perspective, forms in space. In 1904-5, perhaps after seeing Cézanne paintings at the 1904 Autumn Salon, Paris, he introduces a perspective that begins with fixed-ego, wide-view Oriental perspective and then sees forms as nonaligned lying on the same plane which isolates them and allows for individualization. He also sees some of his surfaces enlarged in scale, thus enhancing his color. The results are a highly coherent paintings, original in form and color. This perspective is similar to Oceanic perspective which lacks a fixed-ego and wide-view. See *Le Bonheur de Vivre*, 1905-6, Barnes Foundation, Philadelphia, Pa. In 1907 Matisse introduces a second new perspective, perhaps inspired by African art. Within the context of a wide-view Hellenic perspective forms are seen unaligned relative to the ego. Certain surfaces are again seen enlarged in color. The results are works with great coherence and the immediacy of African art. See *Blue Nude, Memory of Briska*, 1907, the Baltimore Museum of Art. Matisse will use these two perspectives alternately for the rest of his life. Matisse's perspectives differ from Cézanne's in that Matisse's forms are unaligned while Cézanne's ego is aligned to each disconnected form in turn.

Picasso

Pablo Picasso uses nine new perspectives between 1906 and 1912. He began with standard Spanish perspective, round-ego frontal perspective, reduced scale forms in space. See *Moulin de la Galette*, Paris 1900, Guggenheim Museum, New York City. In the fall of 1901 after

seeing prints by Gauguin Picasso adopts peripheral perspective, reduced scale forms in space which increases the immediacy of his works and allows greater individualization. Picasso uses peripheral perspective for the Blue and Rose periods, 1901-1906. See the *Blind Man's Meal*, 1903, Metropolitan Museum of Art, New York City. In the fall of 1906, he introduces the first of nine new perspectives. A form is first seen using round-ego frontal perspective, reduced scale forms in space. The viewer is then oriented to this same form. The change in orientation disconnects the form allowing for drastic differences in scale, size, color, etc. See *Two Nudes*, 1906, Museum of Modern Art, New York City. In May 1907, Picasso invents the first of eight perspectives which I call the Variations on Picasso perspective. Variation I begins with the ego orientated to a form, oriental perspective, reduced scale forms in space. The eyes move to an adjacent form to which the ego then becomes aligned, the new lines of sight isolate the form. The outcome is a composition composed of unique disconnected parts of great immediacy. Picasso uses Variation I for his first version of *Les Demoiselles d'Avignon*, 1907-8, Museum of Modern Art, New York City. Today, only the central two figures and the gray curtain are based on Variation I. During the summer of 1907, Picasso modifies Variation I by seeing his forms oriented to the ego, frontal perspective. Variation II again disconnects forms using initial eye movement. Variation II results in even greater immediacy. The heads of the *Demoiselles* on the right now seemingly constructed from pieces of wood are inspired by African and Oceanic art. Picasso uses Variation II to repaint the two figures on the right, the still life and a blue background curtain. In the spring of 1908, Picasso repaints the figure entering on the left using Variation III. This begins with a form seen using Attic perspective, point beyond reduced scale form in space. The eyes move to an adjacent form and the ego follows. *Les Demoiselles d'Avignon*, as it is today is a record of the first three versions of Picasso perspective. In the summer of 1908, Variation IV appears. The ego is now oriented to a point beyond a form. The eyes move and so on. See *Landscape, Rue des Bois*, 1908, Museum of Modern Art, New York City. A year later, in the fall of 1909, Picasso makes a more significant change by using a fixed ego. Variation V begins with a point beyond a central form oriented to the fixed-ego. Again, the eyes move first and disconnection occurs. The sequence of forms is no longer explained by the moving ego thus rupturing both time and space. See *Still Life with a Liqueur Bottle*, 1909, Museum of Modern Art, New York City. In the fall of 1910, Picasso repaints some of his summer 1910 works using Variation VI. Variation VI reverses orientation, the fixed ego is now aligned to a point beyond a central form. Again, forms are presented as disconnected in both time and space. Extraordinary, dreamlike compositions are a result. Picasso uses Variation VI to paint the shattered images in his black and tan 1910-11 works. In the spring of 1912, Picasso modifies Variation VI using a round fixed ego, frontal perspective and reduced scale disconnected forms now not in space. Variation VII sharpens outlines and brings forms even closer. At this point, Picasso makes his first collage, his Variation VII, *Still Life with Chair Caning*, 1912, Picasso Museum, Paris. He will use Variation VII during the summer of 1912. In the fall of 1912, he repaints some of his summer works using a final variation of Picasso perspective. Variation VIII begins with the fixed ego aligned to a reduced scale form, not in space. Again, the eyes move first disconnecting an adjacent form, disconnection being the simple secret to Picasso perspective. Picasso uses Variation Eight for his drawings with collage of 1912. See *Man with a Hat*, a self portrait, 1912, Museum of Modern Art, New York

City. He uses VIII until the Spring of 1914 when he returns to Variation VII. He will use Variation Seven for the next fifty years alternating it with Variation VIII on five occasions; 1915-17, 1921-23, 1938-1941 and 1965 till his death. I credit Picasso with the discovery of the importance of the visual ego and its actions. It is an achievement unmatched in the history of art.

Cubism.

Cubism begins as the name given to works shown by Georges Braque in 1908. Braque uses a narrow view oriental perspective, forms in space until 1908. See *Viaduct at L'estaque*, 1907, the Mumearah Institute of Art. After visiting Picasso's studio Braque begins nonaligning the divisions between large unit forms in the manner of Old Europe, as he will do for the rest of his life. See *Houses at L'estaque*, 1908, Art Museum, Basel. Nonaligned divisions are also used by the French Cubists, Fernando Leger, Robert Delaunay, and the Spanish Cubist, Juan Gris. Leger uses frontal perspective, forms in space, nonaligned divisions. See *The City*, 1919, Philadelphia Museum of Art. Delaunay also uses frontal perspective, forms in space, nonaligned divisions. See *Eiffel Tower*, 1910, Guggenheim Museum, New York City. Gris uses round-ego, frontal perspective, reduced scale forms in space with nonaligned divisions. See his collage, *Breakfast*, 1914, Museum of Modern Art, New York City. The cubist, Jean Metzinger, uses fixed-ego frontal perspective, forms in space. See *Bathers*, 1913, Philadelphia Museum of Art. The sculptor Henri Laurens uses Hellenistic perspective, forms in space. See *Guitar and Clarinet*, 1920, Hirshhorn Museum, Washington, D.C. The sculptor and brother of Marcel Duchamp, Raymond Duchamp-Villon uses Hellenic perspective, forms in space. See *Horse*, 1930-31, Philadelphia Museum.

German Expressionism

Modernism comes early to Germany under the influence of Post Impressionism and Cubism. Paula Moderson uses Hellenic perspective, forms not in space. See *Self Portrait with Camelia Branch*, 1907, Folkwang Museum, Essen. The colorist Emil Nolde uses this same perspective. See *The Last Supper*, 1909, State Museum for Art, Copenhagen. In Dresden and then Berlin, there is a group of modern artists called the Bridge which will include Ernst Ludwig Kirchner, Emil Heckel, Max Pechstein and Karl Schmidt-Rottluff. The Blue Rider Group in Munich includes the Russian abstractionists: Vasily Kandinsky, the Russian Alex von Jawlensky, the Germans Franz Mark, Lyonel Feininger, Gabriel Munter, and the unique Swiss painter, Paul Klee. Kirchner uses peripheral perspective, forms not in space, until ca. 1913 when he turns to frontal perspective, forms not in space. See his peripheral perspective, *Street Dresden*, 1908, and his frontal *Street Berlin*, 1913, both in the Museum of Modern Art, New York City. Erich Heckel uses peripheral perspective, forms not in space. See Heckel's *Two Men at a Table*, 1912, Kunsthalle, Essen. Peripheral perspective represents a return to German roots, a goal of these

artists. Peckstein also uses peripheral perspective, forms not in space. See *Indian and Woman*, 1910, Saint Louis Art Museum. Franz Mark uses peripheral perspective, forms not in space. *See Large Blue Horses*, 1911, Walker Art Center, Minneapolis, Minnesota. Macke uses Hellenic perspective, forms not in space. See *Great Zoological Garden*, 1912, Museum an Ostwold, Dortmund. The German sculptor Wilhelm Lehmbruck, uses wide-view, peripheral perspective, forms not in space. See *Standing Youth*, 1913, Museum of Modern Art, New York City. Kandinsky uses wide-view frontal perspective, forms not in space. See *Sketch for Composition II*, 1909-10. Guggenheim Museum, New York City.

Futurism

In 1909-10, inspired by the Italian Poet Marrinetti's call for a revolutionary new art, a group of Italian artists, the Futurists, including Umberto Boccioni, Carlo Carra, Luigi Russolo, Gino Severini, and Giacomo Balla begin to pursue this idea. In October 1911, Boccioni and Carra go to Paris, meet with Severini, and there witness Cubism first hand. The Futurists use standard Italian perspective, frontal perspective, reduced scale forms in space with the exception of Balla, who uses fixed-ego frontal perspective, reduced scale forms in space. See *Dynamism of a Dog on a Leash*, 1912, Albright-Knox Gallery, Buffalo, New York City.

De Style

During World War I, the De Style group of Dutch artists forms in the Netherlands. They use Dutch standard perspective, frontal perspective, forms in space, except for their most important member, Piet Mondrian. Mondrian uses Dutch standard perspective until 1913-14, when in Paris, under the influence of Cubism, he adopts peripheral perspective, forms in space. See *Broadway Boogie-Woogie*, 1942-43, Museum of Modern Art, New York City, painted in New York during World War II.

Russian Modernism

Modernism in Russia is led by a group of Moscow artists that begin to make their presence felt in the twenties. Most use standard Russian perspective, frontal perspective, forms not in space. Alexander Rodchenko, a sculptor, painter and photographer, uses wide-view frontal perspective, forms not in space. See his photograph, *Assembling For the Demonstration*, 1928. Kasimir Malivich uses frontal perspective, disconnected forms not in space. See *Suprematist Composition, White on White*, 1918, Museum of Modern Art, New York City. Lyubov Popova a pioneer of Modern Russian art uses fixed-ego frontal perspective, forms not in space. See *Early Morning*, 1914, Museum of Modern Art, New York City.

Modern Architecture

Modern Architecture grows out of the work of such late nineteenth century architects as the Americans Richardson and Sullivan, and most importantly, Frank Lloyd Wright. Wright uses wide-view Oriental perspective, large unit forms not in space. See Wright's early *Robie House*, 1909, Chicago. Modern architecture develops in Europe after World War I. This is lead by the Dutch architect Gerrit Rietveld using standard Dutch perspective. *See Schroder House*, 1924, Utrecht, and the major German architect Walter Gropius who uses fixed-ego frontal perspective, forms not in space. See *Bauhaus Buildings*, 1925-26. Dessau, Germany. The architect Mies van der Rohe, uses this same perspective. See *Spanish Pavilion*, 1937, Barcelona. The German-Jewish architect Erich Mendelsohn designs the *Einstein Tower*, 1920-2l, Potsdam, Germany, in a style reminiscent of Art Nouveau using wide-view oriental perspective, forms not in space. The French/Swiss architect Le Corbusier uses wide-view frontal perspective, forms in space. See *Villa Savoye*, 1929-30, Poissy-sur-Seine. The Italian Giuseppe Terragni uses Hellenic perspective, reduced scale forms in space. See *House of The People*, 19232-6, Como, Italy. The American, Raymond Hood uses fixed-ego frontal perspective, forms not in space. See *Magraw Hill Building*, 1931, New York City. The Brazilian, Oscar Niemeyer uses oriental perspective, forms not in space, the South American standard. See *Palace of the Dawn*, 1959, Brasilia. The English architect, James Stirling, uses wide-view frontal perspective, forms not in space. See *History Faculty*, 1968, Cambridge, England. The American, Richard Meier, uses fixed-ego frontal perspective, forms not in space. See *Douglas House*, 1971-3, Michigan. Another American, Louis Kahn uses wide-view frontal perspective forms not in space. See *Kimbal Art Museum*, 1972, Fort Worth, Texas. Leoh Ming Pei, uses oriental perspective, forms not in space. See *Louvre Pyramid*, 1988, Paris.

Photography

The camera is a machine that by itself can not make a work of art. The focal point of the lens is not a visual ego. However, the photographer using a particular visual ego and the view finder can compose a photograph that is a work of art. Photography is invented in the first half of the nineteenth century. The earliest are based on standard national perspectives. See Jacques Daguerre's daguerreotype, *Boulevard de Temple*, ca. 1838, National Museum, Munich, frontal perspective, forms in space. The English photographer, Henry Fox Talbot uses frontal perspective, forms not in space. See *Trafalgar Square*, 1843, Museum of Modern Art, New York City. A circle of American photographers around Alfred Stieglitz, launches Modern Photography in the United States. Stieglitz uses wide-view Hellenic perspective, forms not in space. See *The Steerage*, 1907. The American landscape photographer, Ansel Adams, uses wide-view frontal perspective, forms not in space. See *Moon Rise*, 1941. The Paris based, Romanian, Brassai, uses wide-view, frontal perspective, forms not in space. See *Dance Hall*, 1932. Photography becomes a major art form after the second World War. The Americans Robert Frank and Lee Friedlander use wide-view frontal perspective, forms not

in space. See Frank's *Political Rally, Chicago,* 1956 and Friedlander's *Washington,* D.C. 1962. Joel Meyerowitz uses Hellenic perspective, no space. See *Provincetown Porch,* 1977. The amazing Diane Arbus uses wide-view frontal perspective, forms not in space. See *Untitled No. 6,* 1979-71.

Modernism in Britain

Modernism in Britain is preceded by the moody works of Walter Richard Sickert. He uses Hellenic perspective, forms not in space. See *Ennui,* 1913, Tate Gallery, London. British Modernism is advanced by the curator and writer, Roger Fry. Most British Modern artists use standard english perspective, frontal perspective, forms in space. This is used by the early English modernist Percy Windham Lewis. See his cubist abstraction, *Composition,* 1913, Tate Gallery, London. The sculptor Henry Moore, the outstanding British Modernist, uses fixed-ego, frontal perspective, forms in space. See *King and Queen,* 1952-53, Hirshhorn Museum, Washington, D.C. The Britain based American, R. B. Kiatage, uses Hellenic perspective, forms not in space. See *Autumn in Central Paris (After Walter Benjamin),* 1972-3, Private Collection.

Early Modernism in the United Sates

Modernism in the United States is proceeded by the so-called Ash Can School. Though relatively conservative, these artists' produce works of high quality. Robert Henri uses Hellenic perspective, forms not in space. See *Laughing Child,* 1907, Whitney Museum of American Art, New York City. The impressionist William Glackens uses Hellenic perspective, forms not in space. See *Chez Mouquin,* 1905, The Art Institute, Chicago. John Sloan who has a splendid eye for detail uses wide-view Hellenic perspective, large unit forms not in space. See the *Wake of the Ferry II,* 1907, the Phillips Collection, Washington, D.C. The most advanced of the group, in effect, a Post Impressionist, is Maurice Prendergast. Prendergast uses Hellenic perspective, forms not in space. See *Central Park,* 1905, Private Collection. The virtuoso George Bellows uses Renaissance perspective, forms not in space. See *City Dwellers,* 1913, Los Angeles County Museum of Art. The first generation of American Modernists painters like the photographers gathers around Alfred Stieglitz. Some had been to Europe to see Modernism first hand and Stieglitz shows Modern European works at his gallery. The American public is made aware of and alarmed by Modernism at the Armory Show of 1913. The works of the first American Modernists are relatively conservative, but high in quality. Max Weber who sees Cubism first hand in Paris uses peripheral perspective, forms not in space. See *Chinese Restaurant,* 1915, Whitney Museum of American Art, New York City. The dexterous John Marin, uses wide-view frontal perspective, forms not in space. See *Lower Manhattan Composition,* 1922, Museum of Modern Art, New York City. The precise Charles Demuth uses-wide-view frontal perspective, forms not in space. See *I Saw the Figure Five in Gold,* 1928, Metropolitan Museum of Art, New York City. Georgia O'Keeffe uses oriental perspective, forms not in space. See *Radiator*

Building, 1927, Fisk University. The abstract painter Arthur G. Dove uses wide-view frontal perspective, forms not in space. See *Nature Symbolized, No. 2*, ca. 1911, The Art Institute Chicago. The peripatetic Marsden Hartley uses wide-view, then a narrow oriental perspective, ego aligned to a point, forms not in space. See *Portrait of a German Officer*, 1914, Metropolitan Museum of Art, New York City. Two early Modern sculptors working in the United States are the Breton Robert Laurent who uses peripheral perspective, forms not in space. See *Flame*, ca. 1917, Whitney Museum of American Art, New York City and the Polish Eli Nadelman who uses Hellenic perspective, forms not in space. See *Man in the Open Air*, ca. 1915, Museum of Modern Art, New York City.

Dada

Dada is an international phenomenon launched during World War I by a group of artists in Zurich. Spurred on by the madness of the war, the Dadaists produce highly inventive works from unorthodox materials and hold performances involving nonsense, music, and noise. The Alsatian, Jean Arp uses wide-view frontal perspective, forms in space. See his relief, *Flower Mountain*, 1916, Foundation Arp, Colment, France. The fabric artist, Sophie Tauber uses African perspective, forms not in space. See *Rhythms Libres*, 1919, Kunsthaus, Zurich. Kurt Schwitters uses wide-view frontal perspective, forms not in space. See *Picture with a Light Center,* 1919, Museum of Modern Art, New York City. During the war, the Dada spirit invades New York brought by European artists fleeing the war. Among these is the unique Marcel Duchamp. Duchamp, who in his early cubist works uses standard French perspective, frontal perspective, forms in space. However, for the *Large Glass, The Bride Stripped Bare by Her Bachelors Even*, executed in New York, 1915-23, Philadelphia Museum of Art, the prescient Duchamp uses accidents and linear perspective to escape the hand of the artist, that is the visual ego. The French name of the work has been identified as a pun on the artist's first name, Marcel, making it a verbal accident. The *Large Glass* is made up of images of manufactured objects and accidentally arrived at elements placed between sheets of glass now cracked, all nonsensical; nevertheless, it has been the task of writers and art historians to divine in it endless meaning.

Surrealism

Surrealism grows out of Dada. It begins in Paris with a group of writers around Andre Breton who are soon joined by painters and sculptors. Surrealism is an effort to unleash the unconscious in making art. The unpremeditated, dreams, accidents, and free associations are used. Sigmund Freud is a great influence. Surrealism takes two directions, more abstract works that exploit suggestive, irrational forms, and what Savator Dali calls "hand painted dream photographs," representational works, conservative in style, with wildly improbable subject matter. Using standard Spanish perspective, round ego frontal perspective, reduced scale forms in space is the Catalan, Joan Miro. See *Harlequin's Concert*, 1924-5, Albright-Knox Gallery,

Buffalo, New York. The Italian pioneer of Surrealism, Giorgio de Chirico, uses an inconsistent Renaissance perspective, reduced scale forms in space to create enigmatic, dream like images. See *Soothsayer's Recompense*, 1913, Philadelphia Museum of Art. The Catalan, Salvator Dali uses fixed-ego frontal perspective, reduced scale forms in space. See *Persistence of Memory*, 1931, Museum of Modern Art, New York City. The Belgium, Rene Magritte uses Renaissance perspective, forms in space. See *The False Mirror*, 1928, Museum of Modern Art, New York City. The Swiss-Italian sculptor and painter, Alberto Giacometti, uses wide-view Hellenistic perspective, forms in space. See *The Palace at 4 A. M.* Museum of Modern Art, New York City. The French, more abstract, Andre Masson, uses wide-view Hellenic perspective, forms in space. See *Battle of Fishes*, 1926, Museum of Modern Art, New York City. The architect Frederich Kiesler uses wide-view frontal perspective. See *Art of the Century Gallery*, 1942, New York City. Surrealism spreads around the world and is still at large today.

European Art, the Nineteen Twenties and Thirties

This is the time in Europe sometimes called the School of Paris. It is a time when Paris is the world art center and artists from all over come there. The School of Paris would include Matisse and Picasso, the Cubists and the Surrealists. Other arrivals include the Romanian sculptor, Constantine Brancusi who uses wide-view, frontal perspective, forms not in space. See *Mademoiselle Pogany III*, 1931, Philadelphia Museum of Art. The Russian-Jewish painter, Chaim Soutine, uses wide-view Hellenic perspective, forms not in space. See *Woman in Red*, 1924-35. Maurice Utrillo uses frontal perspective, reduced scale forms in space. See *Street in Asnieres*, 1913-15, Private Collection.

The United States in the Twenties and Thirties

This is the period of regionalism when a number of relatively conservative American artists focus on local subjects. Also at this time, there are a number of important modernists. Edward Hopper among the conservatives uses Hellenic perspective, forms not in space. See *Early Sunday Morning*, 1930, Whitney Museum of American Art. Thomas Hart Benton a leading Regionalist uses wide-view frontal perspective, forms not in space. See his mural, *City Building*, 1930, collection of the Equitable Life Insurance Company. Jacob Lawrence uses African Perspective for his series *The Migration of the Negro*, 1920-41. The most important American Modernist is the internationally influential sculptor Alexander Calder the inventor of the mobile. Calder uses Hellenic perspective, forms not in space. See his mobile, *Lobster Trap and Fish Tail*, 1939, Museum of Modern Art, New York City. The Modernist Stuart Davis uses frontal perspective, forms not in space. See *Report from Rockport*, 1940, Metropolitan Museum of Art, New York City. The photographer Walker Evans, uses Hellenic perspective, forms not in space. See *Miner's Home, West Virginia*, 1935. Grandma Moses uses Hellenic perspective, forms not in space. See *Checkered House*, 1943, collection of IBM Corporation.

Mexico

In the 1920s, Mexican artists begin producing politically charged murals that celebrate Mexico's past including its Indian heritage. The most famous of these artists is Diego Rivera who studied in Paris. Rivera uses frontal perspective, forms in space, not Oriental perspective. See his Murals, *Detroit Industry*, 1932-35, Detroit Institute of Art. Two famous Mexican muralists who do use oriental perspective, forms not in space, are Jose Orozco and David Siqueiros. See Orozco's Murals for the Dartmouth College Library, *Epic of American Civilization*, 1932-34, Hanover, New Hampshire. See Siqueiros' painting *Scream*, 1937, Museum of Modern Art, New York City. The works of the much admired Surrealist, Frida Kalo, also are based on oriental perspective, forms not in space. See *Self Portrait Between Mexico and the United States*, 1932, Private Collection.

Abstract Expressionism

After World War II, the late forties, there emerges in New York City a group of American artists, the Abstract Expressionists, who are inspired by the European artists and writers who come to the United State during the war; and in particular, the Surrealists with their interest in the use of the unconscious and the accidental in making art. The Abstract Expressionists in marked contrast to Regionalists rejects fine art in general. They eschew traditional technique and highlight the physical application paint which can be individual strokes or broad areas of color. In every case, what is sought is emotionally charged work of art. Apparent haphazardness and spontaneity not withstanding their works are crafted with skill and under control of the visual ego. The Armenian Archile Gorky uses peripheral perspective, forms not in space. See *The Liver is a Cock's Comb*, 1944, Albright-Knox Gallery, Buffalo, N.Y. The Dutch Willem de Kooning, uses Hellenic perspective, forms in space. See *Woman II*, 1953, Museum of Modern Art, New York City. Jackson Pollock uses fixed-ego frontal perspective, reduced scale forms not in space to control his famous "drip" paintings. See *Autumn Rhythm*, 1950, Metropolitan Museum of Art, New York City. Lee Krasner uses wide-view frontal perspective, forms not in space. See *Celebration*, 1959-60, Private Collection. Robert Motherwell uses wide-view Hellenic perspective, forms not in space. See *Elegy to the Spanish Republic*, 1953, Albright-Knox Gallery, Buffalo, N.Y. Mark Rothko uses Hellenic perspective, forms not in space. See *Ochre and Red on Red*, 1954, Pillips Collection, Washington, D.C. Phillip Guston uses Hellenic perspective, forms not in space for his *Zone*, 1953-54, Private Collection. The less abstract, Milton Avery, uses oriental perspective, forms not in space. See *Swimmers and Sunbathers*, 1945, Metropolitan Museum of Art, New York City. Concurrent with Abstract Expressionism is a group of abstract sculptors most of whom use standard perspective. David Smith uses fixed-ego frontal perspective, forms not in space. See *Cubi, XVIII*, 1964, Boston Museum of Fine Arts. Louise Nevelson uses Hellenic perspective, forms not in space. See *Black Chord*, 1969, Private Collection. The Japanese-American, Isamu Noguchi uses oriental perspective, large unit forms in space. See *Kouros*, 1944-45, Metropolitan Museum of Art, New York City.

Pop Art

Pop Art, a new style, a new aesthetic, follows close on the heels of and often mocks Abstract Expressionism. Pop Art returns to representation using banal commercial art as a source. Much of Pop Art is highly sophisticated, skillfully produced, makes insightful social comments and lacks the empty dullness and ineptness of the most ordinary of commercial art. The English, Richard Hamilton, a pioneer, uses standard english perspective. See his collage *What Makes Today's Home So Different, So Appealing?* 1956, Kunsthalle, Tubingen, Germany. Robert Rauschenberg and Jasper Johns uses Hellenic perspective, forms not in space. See Raushenberg's *Bed*, 1955, Museum of Modern Art, New York City and Johns' *Flag*, 1954-55, Museum of Modern Art, New York City. The Swedish sculptor, Clause Oldenburg uses wide-view Hellenic perspective, forms not in space. See *Soft Toilet*, 1966, Whitney Museum of American Art, New York City. The American sculptor George Segal uses wide-view frontal perspective, no space, for *Cinema*, 1965, Albright-Knox Gallery, Buffalo, N.Y. Jim Dine uses Hellenic perspective, forms not in space. See *Double Isometric Self Portrait*, 1964, Whitney Museum of American Art, New York City. Larry Rivers uses Hellenic perspective, forms not in space. See *Dutch Masters and Cigars II*, 1963, Private Collection. James Rosenquist uses Hellenic perspective forms not in space. See *F111*, 1965, Private Collection. Andy Wharhol also uses Hellenic perspective, forms not in space, but when he combines a series of his prints into larger compositions, the parts are disconnected. See his screen print, *Marilyn Monroe*, 1962. The Californian, Wayne Thiebaud, uses Hellenic perspective, forms not in space. See *Pie Counter*, 1963, Whitney Museum of American Art, New York City. The unique Jes uses Hellenistic perspective, forms not in space. See *Will Wonders Never Cease?* 1962, Hirshhorn Museum, Washington, D.C.

Post Modern Architecture

Post Modern Architecture is an offshoot of Pop Art that is a systematic critique of Modern Architecture in a quest for a new, more open architecture. Postmodern Architecture is inspired by popular culture, vernacular commercial architecture and even the gaudiness of Las Vegas. A characteristic of Postmodern Architecture is the use of peripheral perspective. This replaces Modern's use of frontal perspective which leads to buildings marked by their continuity. Postmodern buildings are a sequence of parts that allows for the unexpected including ornament and even the classical orders. Robert Venturi uses peripheral perspective, forms not in space. See *Chestnut Hill House*, 1962, Pa. Other Post Modern architects using peripheral perspective are: Charles Moore, *Piazza Italia*, 1975-8, New Orleans; Peter Eisenman, *Center for the Arts*, 1983-89, Ohio State University, Columbus, Ohio; the Dutch architect and writer, Rem Koolhass, *Netherlands Dance Theater*, 1987, The Hague; the English architect Norman Foster, *Telecommunications Tower*, 1992, Barcelona; the American Robert Stern, *Pool House*, 1981-2, Lewelyn, New Jersey and the "neo cubist," Richard Ghery, *Guggenheim Museum*, 1992-7, Bilbao, Spain.

Post World War II

Since World War II, there are numerous important artists whose work does not fit such categories as Abstract Expressionist, Pop, or Minimalist. Most use standard perspectives. An exception is the Norwegian abstractionist, Asper Jorn who uses wide-view frontal perspective, no space, *See Green Ballet*, 1960, Guggenheim Museum, New York City. The Italian still life painter Giorgio Morandi surprisingly for an Italian uses frontal perspective, forms not in space. See *Still Life*, 1951, Kunstsammlung, Dusseldorf. The American, Elsworth Kelly, uses Hellenic perspective, forms not in space. See *Orange and Green*, 1966, Private Collection. The Czech photographer Joseph Sudeck uses wide-view frontal perspective, forms not in space. See The *Window of My Studio*, 1954. The German, Deiter Roth, uses wide-view Hellenic perspective, forms not in space. See his silk screen prints, *Six Piccadillies*, 1969-70. Another German, Anselm Keifer, uses Renaissance perspective, forms not in space. See his *Germany's Spiritual Heroes*, 1973, Private Collection. Nicolas de Stael uses wide-view Hellenic perspective for *Agrigente*, 1954, Museum of Contemporary Art, Los Angeles. The German George Baselitz uses Hellenic perspective, forms not in space. See *Torso*, 1990, Private Collection. The American portraitist Alice Neel uses Hellenic perspective, forms not in space. See *Portrait of Andy Warhol*, 1970, Whitney Museum of American Art, New York City. Another American who uses Hellenic perspective forms not in space is Elizabeth Murray. See *Careless Love*, 1995-6, National Gallery of Art, Washington, D.C. The Californian, Richard Diebenkorn uses wide-view frontal perspective, forms not in space. See *Man and Woman in Large Room, 1957*, Hirshhorn Museum, Washington, D.C. The photographer-collagists, Mike and Doug Starn, use-wide-view frontal perspective, forms not in space. See *Double Self Portrait with Mona Lisa*, 1985-89, Boston Museum of Fine Arts. The American sculptor, Martin Puryear, uses African perspective, forms not in space. See *Old Male*, 1958, Philadelphia Museum of Art. Ed Rossbach the remarkable California textile artist uses wide-view frontal perspective, forms not in space. See *Good Omen*, 1988-90, Farago Collection, Museum of Fine Arts, Boston.

Postmodern Art

Beginning in the second half of the twentieth century, there is an effort to escape the limits imposed by the visual ego through a critique of the past and Modern art in particular for the sake of a more open, more relevant works. Ironically, this effort also confirms the importance of the visual ego to art. Postmodern art takes a number of directions, including minimalism, conceptual art, performance art, land or earth art, process art, and installations. The roots of Postmodernism lie in the first half of the twentieth century, but aspects of Postmodernism can be found throughout art history. More recent forerunners include, Cézanne's and Picasso's use of disconnection, modernism in general, Dada, Marcel Duchamp, Surrealism, Abstract Expressionism, Kazimir Malevich's use of disconnected shapes and Pop Art. The minimalists take a further step away from the past. Many of their works are formally very simple and include natural, non-art elements, practices intended to open up a work to the "real world"

and so expand meaning and relevance although simplifying form tends to reduce meaning. Frank Stella's uses a narrow oriental perspective for his rectilinear compositions of disconnected elements in a quest for "flatness." *See* his *Black Paintings*, 1960s. Tony Smith uses nonaligned, elemental geometric forms in space set against nature. See *Die*, 1962, Private Collection. Donald Judd's sequences of disconnected, frontal perspective *Iron Boxes*, untitled, 1960s. The boxes although lined up are separated by disconnected natural spaces. Robert Morris's Installations of elemental, disconnected frontal perspective objects are designed for a particular spaces, yet are not coherently connected either to the place or each other. See *Cloud, Boiler, Floor Beam, Table*, 1964 installation, Green Gallery, New York City. Sol leWitt's frontal perspective *Linear Designs on Walls*, 1970s are made up of frontal perspective, disconnected shapes not in space and are not coherently related to their rooms. Richard Serra's assemblage of massive, nonaligned, disconnected metal plates, are to be seen in locations to which they are not coherently related. See *One Ton Prop*, 1969, Museum of Modern Art, New York City. Robert Smithson's frontal perspective, earth work, *Spiral Jetty*, 1970, Great Salt Lake, Utah, encloses and is surrounded by disconnected water that is part of the composition. Dan Flavin's composition, *Column Installation*, 1969-70 is made of commercially manufactured light fixtures which are disconnected and not coherently related to their surroundings. Process art is designed to be transient events transformed by the forces of nature and not the action of an artist, and so are not art although the practice is to call them such. See Robert Morris's *Steam Sculpture*, 1967-73. Performance art is temporary, and there may be some sort of previous scheme, this is not the experience. The result is a sort of theater that lacks the coherence given by dialogue, choreography, setting, music, and actions of a normal theatrical performance. See Bruce Nauman's *Self Portrait as a Fountain*, 1966-70, a photograph. Conceptual Art can be described acts that are not necessarily carried out yet deemed works of art. Here the visual ego almost entirely disappears except for writing and disconnected objects. It is not these but the ideas they engender that are to be the work. See Joseph Kosuth's *One and Three Chairs*, 1965, The Museum of Modern Art, New York City.

Post Modern Art History

Postmodern art history continues art history's emphasis on context, the external worlds past and present that surround the work of art and not the internal world that is the work of art. Context is often understood as a dynamic, potentially limitless swirl of ideas and images which are not all knowable. Context is conveyed by language, so a study of language becomes important. The context is understood to invade both the mind of the artist and that of the viewer, writer or art historian. The context being not all knowable leaves the viewer, writer or art historian free to pick and choose what part to relate to a work. This can be done using political, social, economic, historical, psychological, psychiatric, or gender criteria or all of the above or anything else. This guide to looking at art is directed to the work of art as a closed system with the relevance of context being determined by the internal structure of the work. Concomitant with ideas about context there is the idea that the author or artist and the work are only a conduit for images and ideas flowing consciously and unconsciously from the context

to the viewer, writer, or art historian who responds again in context to determine the meaning or meanings of the work. With this scenario, the writer or art historian becomes the ultimate creator. This is just wrong. The response to a work of art is not part of the work, and if the response is based on an incorrectly seen work, it is probably irrelevant. Besides, who would rather read about the *Sistine Ceiling* than look at it? Unfortunately, maybe an art historian? Art History's fixation with context seems to result from a long standing mistake. That is that reason and aesthetics are separate ways of thinking and that aesthetics is the inferior. This attitude which privileges content over form and the scholar over the artist carries with it a traditional prejudice against manual labor and for that matter, women. Here, knowledge and beauty are treated as fundamentally linked. Not understanding what constitutes a work of art is another basic mistake. The work of art is a closed system controlled by the visual ego and not a passage between vast, potentially endless contexts. A works of art is a structure governed by the particular use of the visual ego the understanding of which depends on experiencing the work using the correct visual ego. When the visual ego and resulting forms are neglected, misunderstood, relevant context is obscured and what is written can become largely fiction. It is possible that the ego ordered visual world is a defining attribute of modern human beings, Homo sapiens sapiens. While an improved definition of form would have been valuable for hunting and foraging the aligned visual world has other advantages. Our thoughts involve a stream of images and words. The ego gives order to this mix and makes it possible to communicate thoughts by turning then into language. Language is a system of sounds, whether physical or imagined, perceived in an imagined space governed by the ego. Language is composed of letters, sounds that are combined into words that are given meanings. Words are combined into sentences. To make a coherent sentence a consistent use of the visual ego is necessary. Without coherence, meaning is lost. So language qualifies as an art form being governed by a particular use of the ego. As the visual ego creates the framework that configures the painting, so the ego orders our thoughts and makes them communicable. The coherent communication of thoughts is essential to society. Thus, the particular use of the visual ego makes civilization possible. The link between language and the visual ego is demonstrated in the history of art by the connection between the languages and the perspectives used by various early peoples. Peripheral perspective is used by the Indo-European speakers, frontal perspective by those speaking Semitic languages and oriental perspective by speakers of oriental languages.

Our brain presents us with an upright, stable optically structured visual world. The visual ego places us at the center of this world so that wherever we look objects are seen lined up with us. We organize and make compressible the visual world by isolating its parts and regularizing their relationships geometrically. In this same way, we make a work of art. Nature is a great source of ideas and images, knowledge and beauty, but nature seems endless, ambiguous, and contradictory. A work of art is finite. It makes a statement that in contrast to nature establishes its and our separate being. As such, it is akin to religion. Art is here to stay. It is in our genes.

Notes

[1] The visual ego described here differs from what Ernest Mach calls the phenomenal ego and James J. Gibson the visual ego. In both cases, the ego is described as a visual field including portions of the viewer seen with one eye. Here, the visual ego is described as an unseen entity which is the viewer, and is understood by its relationship to objects in the visual world. *See* James J. Gibson *The Perception of the Visual World*, 1950, 27 and 225.

[2] A change in orientation would explain such classical optical illusions as the Muller-Lyer and the Moon. Following Richard L.Gregory's suggestion in *The Intelligent Eye*, 1970 that the Muller-Lyer Illusion is the result of inappropriate constancy scaling it would seem that the apparent difference in length of the equal length shafts of the Muller-Lyer "arrows" is explained by the "shorter" automatically being seen using the large ego, oriental perspective and the "longer" being seen using the small ego, frontal perspective, on the basis of the "shorter" being the corner of a distant object and the "longer" being the inside corner of a close by object. In the same way, we automatically see the apparently large rising moon using the small ego and the large ego when the moon is high in the sky.

[3] *See* Brian M. Fagan, *The Journey from Eden, The Peopling of Our World*, 1990.

[4] These include works in the African Tradition. Large unit composition is also a characteristic of Japanese art, the works of Lysippus, Praxiteles, Ghiberti, Michelozzo, Leonardo, Michelangelo after 1510, Bronzino, Caravaggio, Frans Hals,Velazquez, Poussin, Chardin, Ingres, Delacroix, H. H. Richardson, A. Saint-Gaudens, L. Sullivan, F. L. Wright, Seurat, van Gogh, Cézanne, Matisse, Picasso after May 1907, Malevich, Giacometti and Oldenburg.

Printed in the United States
By Bookmasters